JOHN CONSTABLE

JOHN CONSTABLE

A biography — 1776-1837

by

FREDA CONSTABLE

TERENCE DALTON LIMITED

LAVENHAM . SUFFOLK

1975

Published by
TERENCE DALTON LIMITED
ISBN 0 900963 54 9 ✓

Text set in 11/12 Baskerville Typeface

Printed in Great Britain at
THE LAVENHAM PRESS LIMITED
LAVENHAM SUFFOLK

For
my Husband and my Son
John Constable

CONTENTS

INDEX OF ILLUSTRATIONS

ACKNOWLEDGEMENT AND INTRODUCTION

NO ARTIST can be completely separated from his work and in the case of John Constable R.A. his painting and his life are particularly closely interwoven. Indeed so well known are some of his pictures that they obscure the man himself. This book is an attempt to give the story of his life against the background of his work and if it gives the reader a new look at both it will have been successful. The Suffolk Records Society has published in several volumes the vast amount of correspondence by Constable and these are essential for further reading while Graham Reynolds' *Constable the Natural Painter* is a most lucid survey of the paintings.

The sudden death of my father-in-law, Lieutenant Colonel J. H. Constable, when the manuscript was nearing completion robbed me of his comments and corrections. So I must acknowledge his help with family documents and background and take on myself responsibility for my mistakes.

Thanks are also due to the private and public collectors who have allowed me to reproduce pictures and letters in their possession. And to my husband and son for their support and, almost always cheerful, suffering while the book was in preparation.

<div align="right">Freda Constable</div>

Ipswich, Suffolk.
September, 1975.

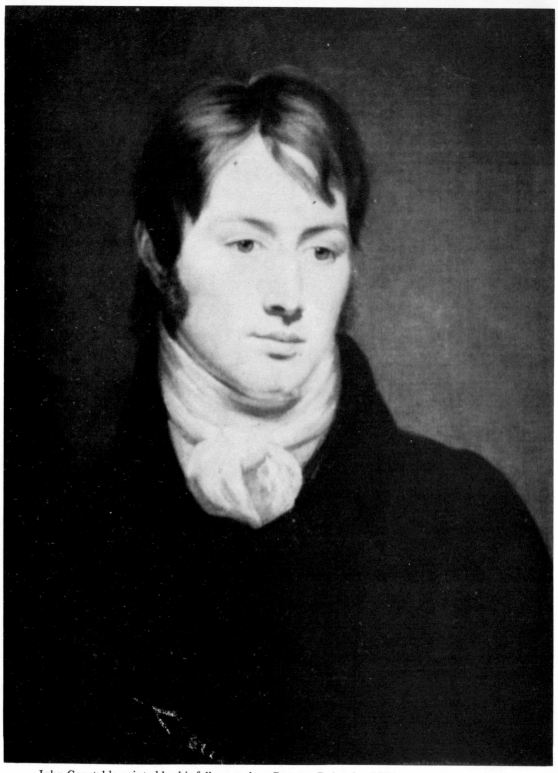

John Constable painted by his fellow student Ramsey Reinagle c1798.
National Portrait Gallery *Oil on canvas* *76 x 63.5 cm.*

CHAPTER ONE

"The best of England was always provincial England, and the happiest people lived their uneventful lives in small country houses."

R. J. White, *Life in Regency England.*

O N THE night of 11th June, 1776, the Reverend Mr Driffield was hurried across East Bergholt Common to baptize a newly born child whose weakly condition did not bode well for his survival, and it was believed that baptism would smooth his way in the next world. The name given to the child that night was John Constable which was to become one of the greatest names in English art. However, at that time it was simply a traditional name given to, and long established amongst, the Constables who had farmed along the Stour valley lands for generations.

The boy was born into the end of the period when England had been established in the form and position still thought of as the best in its history. John Bull of the Georgian era stands for those qualities of ample simplicity and comfort allied to judicious and civilised, but not over-cultured, behaviour which the English love to see in themselves. This way of life evolved during the eighteenth century, due mainly to the rise to substantial wealth of the merchant class into which John Constable was born.

His father, Golding, was the son of John Constable of Bures and in 1764, at twenty-five, he inherited from his paternal uncle, Abram, land in East Bergholt, Flatford Mill, shipping, stock and cash and goods. Abram evidently showed good sense in his choice of heir for Golding was soon able to buy another larger mill at Dedham in addition to a windmill and round house at East Bergholt. The river Stour had been made navigable from Mistley to Sudbury in 1705-6 and by the middle of the century corn had become the staple crop of the area and mills for grinding corn had replaced the old fulling mills. Previously these had been party to the area's other great rise to wealth, that of the wool industry of the Middle Ages when Suffolk became one of the wealthiest counties in England and "the ribs of the whole world were kept warm by fleece from English wool".

East Bergholt itself had been involved with the manufacture of cloth "bays" for which Colchester had been a centre, but by Golding's time the emphasis had moved on to corn and flour which travelled from the heartland of Suffolk down the Stour to Mistley, then one of the larger Essex ports, and away by coastal shipping to London. As part of his business he often had to travel up to the corn market in Mark Lane, but the capital with its oppressive air made more un-

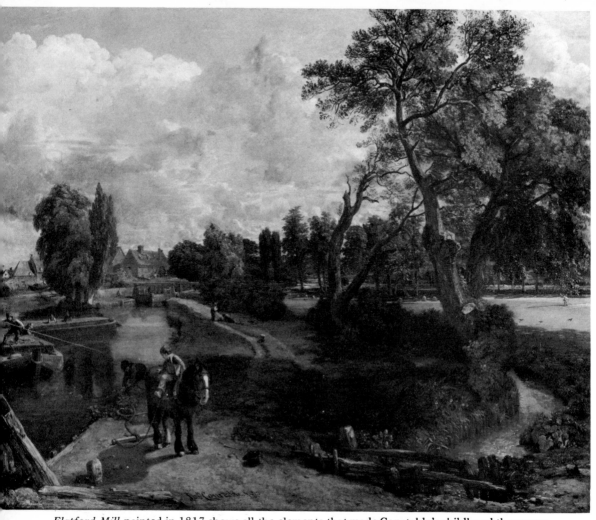

Flatford Mill painted in 1817 shows all the elements that made Constable's childhood the source of idyllic memories and through his pictures have come to epitomise the English countryside.

The Tate Gallery, London *Oil on canvas* *101.5 x 127 cm.*

pleasant by the fact that every building burnt coal and caused a perpetual fog of smoke and grime to hang over the streets was not to his liking. However, it was probably on one of these visits that he met Ann Watts, who became his wife.

Nine years younger than her husband, she was the daughter of a respectable City family, her father being a successful cooper who was able to educate his children well and give Ann a good dowry. She was married shortly before her nineteenth birthday and the match seems to have been entirely successful. A shrewd, energetic, independent character and a sympathetic imagination made more worldly by her London background balanced her husband's solid, rural

stability and they both shared strong pious traits and concern for moral virtue, respectability and charity. Between them they could provide a stable basis for bringing up the family they started after settling in Flatford Mill. Three children, Ann, Martha and Golding were born to them there and the mill house was soon too small, so Golding had a substantial house built up in the village of East Bergholt on the main street near the church. It was designed on the modern square block plan and consisted of four ground floor rooms with a spacious entrance hall, four sleeping rooms with light closets and a good sized landing and four attics. Cellars for wine, brick stables and coach house and "every convenience that can be thought of" made it a feature of the village. Stretching away behind the house were barns and arable and pasture land which provided a flower garden

East Bergholt House built in 1774 by Golding Constable to give his growing family more room than Flatford Mill could provide. The house was demolished in the mid-nineteenth century and only a utility wing, later converted into cottages, remains.

Family collection *Watercolour* *14 x 17 cm.*

with shrubs, beds and walks and kitchen gardens to supply the house, as well as accommodation for the horses and cows and gave hay for their winter feed. Life in East Bergholt House was a comfortable balance between the country estate — for it must have been largely self-supporting — and the business life, for the family were not dependent on making their living from their land.

John was the first child born in the new house and he was followed by Mary and Abram. Mrs Constable must have been a woman of great capabilities to be able to run a large household, bring up six children, support her husband in what was always a hard business and take an active part in the social affairs of the neighbourhood. She would seem to have been as capable in superintending the brewing and dairy work as she was careful in carrying out the proper niceties of country society. A strong believer in charity and responsibility to those less fortunate she thoroughly instilled this belief into her children. But she did not rusticate in her country home; strong links were maintained with her London relations and these, with exchanged visits, opened the door to town life for the children. Her portrait shows a determined, controlled yet kindly woman at home with her dog on her lap, but on her London visits she kept up with all the latest events and could hold opinions on them as positive as she had on the management of her poultry yard. The influence, both indirect and actively direct, she had on her second son's character and career was very strong.

Being part of the small world of a large country family connected with the main activity of the valley within which it lived made the early childhood of John Constable the ineradicable source of his feeling for nature. The country life he saw was very busy, everything was connected with the land, people worked on it and it was made to work for them. A god-given partnership in which he felt a natural place. And through the wide valley ran the Stour. If, as George Ewart Evans has said "the *work* is the biggest single factor in determining a region's character" then the importance of the working of the river and canals in the Constable country cannot be over emphasised. But the effect on the young boy growing up there was allied to an awareness of the natural beauty which the river brought.

There must have been rides up and down on the barges, the idyllic effect of gliding along under reflections of light from the overhanging trees being a natural complement to all the bustle that went on when the boat reached the lock or when the tow path changed banks and the barge horse had to be taken on board and poled across to the other side. Fishing was popular with the Constable boys and when they tired of this there were the woods and fields to roam in. As they grew up the mechanics of the mills interested them, the sounds and smells of grain and flour mingled with timber, water, oil and machinery became as much a part of them as the changing seasons.

And something else would have impressed them — the fact that their father's mills were important and vital. England was still essentially an agricultural com-

munity despite the advances made in industrial techniques; Telford the great road builder believed improved communications would benefit agriculture more than industry, and the quality of each year's harvest was still the greatest factor in the general state of the country as a whole. A bad one meant increased imports, credit restrictions and general unrest while everyone felt the impetus from a good one. The rising population increased the demand for bread and meat so that in the 1780s England ceased being a grain exporting country and had to import some to meet her needs, but it was generally a very optimistic time for agricultural interests and soon economic gain joined fashion as a reason for agricultural improvement. East Anglia had never been an area for looking backwards, its independent attitudes were probably already formed in the time of the Domesday Book when Suffolk was the most densely populated county in England and — more important — it contained over half the total number of recorded freemen in the whole country.

During the following centuries it had produced men and methods to compete in the economic battle for survival. In the eighteenth century many of the new crops and cultivation methods and implements originated in East Anglia. And when, in 1793, the semi-official Board of Agriculture was set up it was a Suffolk man, Arthur Young, who was the secretary. It was, therefore, in an atmosphere of thriving tradition that Constable grew to understand the working of the countryside.

Flatford Mill itself became the centre of his memories. Standing on an ancient site which may have been occupied by a mill before Domesday — for Flatford stood at the lowest regularly passable crossing point of the Stour — it was by the time of Henry VIII a "water and fulling mill". In 1689 it was in a ruinous condition, but its fortunes rose with the development and canalization of the river and the ownership of, first, Abram and then Golding Constable. To a child it presented endless exciting things to do and see.

The Constables were described as living "in genteel style" and their position in the village, in addition to being on social terms with the right people in Dedham, Ipswich and Colchester, gave their children assurance and security to last a lifetime. Manners were an easy round compared to the proscribed rituals of the nineteenth century but their position in society made the childrens' education of some concern. There was no state system, old grammar schools existed and academies for young ladies and gentlemen but things were generally haphazard. For Constable school brought the only dark episode of his childhood: he was sent from his home to be a boarder at Lavenham Grammar School. An usher there who beat the boys gave him a burning and lifelong hatred of schools, and made him so unhappy that he was soon removed, and until seventeen he attended as a day boy the school in Dedham run by Dr Grimwood. From the portrait of his

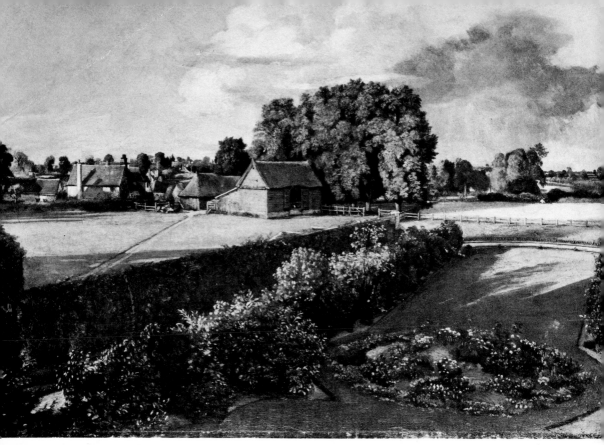

Golding Constable's Flower Garden, a view taken from one of the back bedroom windows of East Bergholt House. Probably painted in 1815.

Christchurch Mansion, Ipswich *Oil on canvas* *32 x 49.5 cm.*

master, now in The Minories, Colchester, which Constable later painted we see a solid typical eighteenth century face, not unlike Golding himself.

One cannot imagine him pressuring boys into ambitious careers, but giving them just enough culture and the basis needed for lives as country worthies and god-fearing Englishmen. With John Constable, perhaps, he had some difficulty for the boy was dreamy and, as he later admitted, spent much time making up pictures in his head long before he actually started painting. But it was a happier arrangement, he lived at home and each day passed through his beloved valley. No one subject captured his special interest at school, although he is said to have excelled in penmanship. In later life he showed himself to be widely read and knowledgeable but regarded this as the result of his own work and nothing to do with his schooling. His letters are fluent even though his penmanship declined and is as a rule a puzzle to decipher.

By the time he left school it was already apparent that his elder brother Golding, being epileptic, could not follow their father into the business and so the choice had to fall on John. Family life in the Constable home appears to have been very harmonious, the children being as devoted to their parents as they were themselves cherished. John may have already formed resolutions regarding painting, but it was expected that he should now learn the family business and so he became a working part of that ordered life he had seen since he was a child.

In a cottage beside the front gate of East Bergholt House lived John Dunthorne, the village plumber, glazier and atheist. At some time during the adolescence of John Constable they started painting together and Dunthorne, six years the senior, can be credited for being the first influence on the artist. He had evidently married a widow of East Bergholt under slightly mysterious and not altogether happy circumstances, for Mrs Constable, in a letter to her son, said, "You do not exactly think with me when you say, Dunthorne's old woman's conduct has always been of the worst kind towards him! To herself it has certainly proved so — to take in a man, from an advertizement, without a change of raiment or a

A companion, *Golding Constable's Kitchen Garden*, extends the view from East Bergholt House over the broad Suffolk landscape.

Christchurch Mansion, Ipswich *Oil on canvas* *32 x 49.5 cm.*

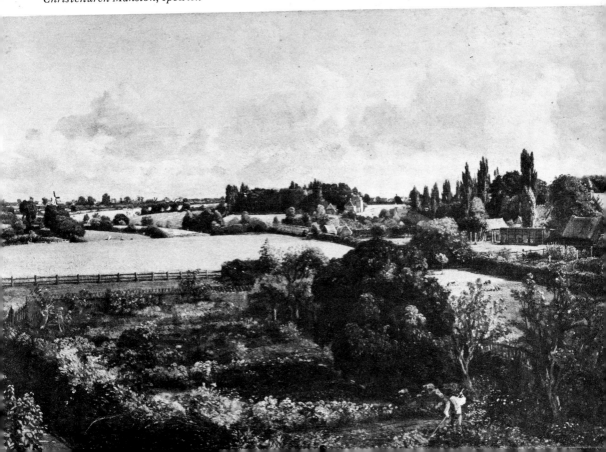

shilling in his pocket and marry him — put him in possession of her house, furniture, trade, and what property she had — surely he ought to be grateful at least." Independent of nature he remained all his life and in the village, though he was thought uncouth and rough mannered, he stayed doing the odd painting job such as inn signs in addition to his other trades.

He it was who must have provided Constable with the physical wherewithal to start painting and from him the younger man is said to have quickly learned the habit which he later maintained, that of painting from one spot at a certain time of day, leaving off when the light effects changed to return another day when the specific effect was repeated. Thus from the very start of his painting life Constable absorbed a sense of truth to nature and actuality. This friendship came at the perfect time to act as catalyst on the schoolboy's daydream pictures. With a brush held awkwardly in his hand for the first time and all the things he had thought of painting crowding into his mind he must have seen infinity opening before him. His earliest painting is not known but it is a reasonable guess that it would have been the river and its locks which gave immediate challenge to his brush. He was aware from his long knowledge of the valley of every sight and sound which pleased him. The rides through it on land or water had taught him how with each twist and turn of path, road or the river a different view was found, and all centred on the tower of Dedham church acting as fulcrum to the countryside as it was to do in his pictures. The constantly changing viewpoint, the ever-moving clouds and the differing effects they bring and the ordered chaos of the river traffic were already a part of him and Dunthorne now gave him the opportunity and means to express them on canvas.

Golding cannot have been pleased with such a friendship at the time when he most needed this son to settle down into the business but he did not prevent it. Eighteenth century parents were on the whole indulgent to their offspring and the *paterfamilias* of the Victorian age had not yet been born, but whether Golding would have allowed John eventually to follow his artistic career had not Abram been willing and able to take over in his place is another matter. His face shows the solid sense of the independent Suffolk farmer who would not willingly see all he had worked for being lost for the sake of something so unprepossessing as Art. Fortunately, when the time came, Abram was able to take responsibility for the future of the mills, but at the moment it was not necessary to consider this problem. John settled down to learn all he could and for a year he worked hard studying the working of water and wind mills and that ever-present weather. With the exception of seamen no-one has been so dependent on close study of weather conditions than the men who worked the windmills, and the need to take advantage of the wind when it came has contributed to the reputation for avarice which millers have acquired down the centuries, sometimes working through the night if the right wind came along. Constable carried out his duties with care and interest.

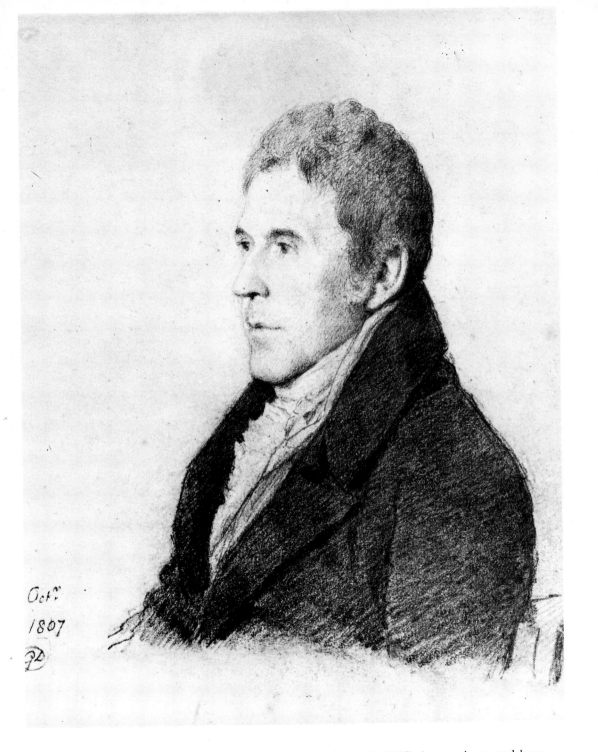

Octr
1807

Sir George Beaumont (1753-1827) drawn by George Dance in 1807. A connoisseur and keen artist himself, Beaumont introduced the young Constable to works by the great masters in his collection which eventually enriched the newly formed National Gallery.

National Portrait Gallery *Pencil* *23 x 18 cm.*

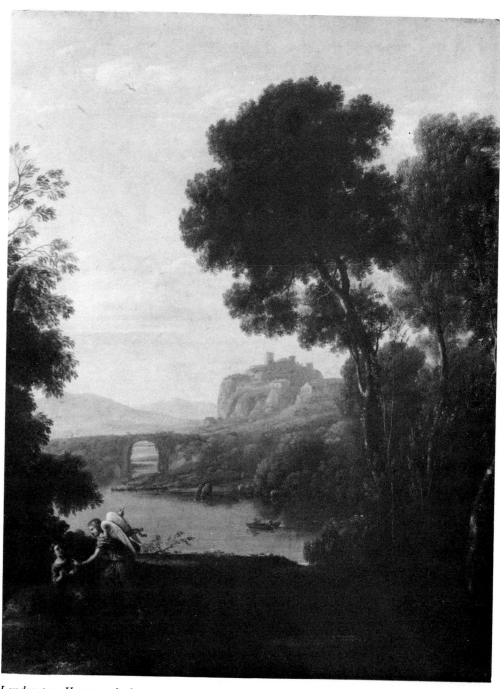

Landscape: Hagar and the Angel painted by Claude in 1646. Constable regarded his introduction to this picture as one of the most important events in his life.

Reproduced by courtesy of the National Gallery, London *Oil on canvas* *52.5 x 44 cm.*

He certainly retained and made use of what he observed, for in later years his brother Abram said to C. R. Leslie, "When I look at a mill painted by John, I see that it will *go round*, which is not always the case with those by other artists." And right up to the end of his life Constable was consulted by Abram as to repairs on the mill machinery, making easy reference to the technicalities in such a way that suggests that the artist was still regarded as someone closely involved with the milling work.

If his parents allowed the painting to continue, hoping that it would wear itself out, they were wrong. With so much more to put down Constable's need to paint grew. Mrs Constable cannot have approved Dunthorne as sole influence on her son so she obtained an introduction for him to Sir George Beaumont whose mother lived at Dedham, which was a discreetly fashionable country retreat at that time. Sir George represented the better side of Art to Mrs Constable for he was one of the most noted collectors and connoisseurs of his day and no mean painter himself. Being an aristocrat he was the respectable and even enviable side of painting to balance the undesirable element which Dunthorne stood for in his humble and uncouth way. Beaumont was pleased with some drawings Constable showed him and so set in motion a life long friendship. Although he never really appreciated the younger man's painting and often took the irritating stance of mentor his generosity and hospitality were of prime importance in Constable's career.

A man whose wealth came from coal mines, he had enjoyed a cultured upbringing and at Eton was taught by Alexander Cozens, he had made the Grand Tour and counted Reynolds, Gainsborough and Wilson among his friends. His passion for painting was only equalled by his enthusiasm for the great masters and his collection provided one of the best introductions a young artist could have of Claude, Rubens or Rembrandt for there were no public collections to be visited at will. England had great pictures in plenty but to see them it was necessary to be introduced to the owners. Beaumont proved himself a true patron for he also collected works by modern artists and through dinners at his London house or visits to Coleorton, his country estate, he provided meeting grounds for painters, writers and poets. His commissions were sometimes more harrassing than they were worth as he had very definite ideas on what he wanted but he is one of those men whose taste and ideas form an indispensible part of his age.

In Dedham he gave two highly important 'introductions' to Constable. The first was to a small painting by Claude, *Hagar and the Angel,* which Beaumont later gave with many other great pictures to the formation of the National Gallery. He was so fond of this painting that he took it with him wherever he travelled. The second 'introduction' was to the watercolour painting of Thomas Girtin. This young artist had also enjoyed a childhood centred on a river — the Thames at London — and the effects of water and air were very important to his paintings.

The freshness and vigour of these were to have a profound effect on Constable's oils and the *Hagar* was a picture he returned to with awe and affection all his life.

The Italianate valley Claude shows may be a long way from the Stour but in the young man's vaguely formed vision of *his* valley, with its distinctive light effects and expanse of water, the spark flashed and the synthesis formed filled his work for the next thirty years until the death of his wife when the sun set on the idyllic countryside. The light in Claude's little picture is all pervading, it creates and shapes forms, it penetrates distance and, when obstructed, it works just as strongly through shadow. In a part of England known for its light the Stour valley is particularly individual in the luminosity which its formation and the closeness of the sea bring to it and the effect on an artistic consciousness is potent and intrinsic. With his social contacts in the houses of the area Constable must have been aware of the reasonably good art to be seen on their walls, but this was probably his first experience of *great* art. Mrs Constable had arranged the meeting with Beaumont with her son's interest at heart. She may have regretted it for the sight of such pictures increased his interest and there must soon have been two increasingly worried parents in East Bergholt House.

To add to this their son was widening his circle of friends interested in Art. Somehow, perhaps through one of his friends in the town such as Mrs Cobbold, he met and visited George Frost of Ipswich and this was to be another fruitful contact. Mrs Cobbold herself was interested in the arts and achieved fame as the employer of Margaret Catchpole when her son, the Reverend Richard Cobbold, wrote the romantic story of this local heroine. Frost was considerably older than Constable, having been born near Bury St Edmunds in 1745. He was the son of a builder but spent fifty years of his life as clerk in the office of the Blue Coach which ran between Ipswich and London, living in Brook Street near the *Coach and Horses Inn* and later on the Common Quay. He acquired some reputation in the town as a worthy citizen and as a drawing master. He had plenty of free time from his none too arduous duties in the office to spend on his favourite pursuit, making drawings and watercolours of the town and its surroundings. Gainsborough was Frost's god and he owned a number of the Sudbury artist's works, drawings and at least one painting which Constable would have seen on his visits.

Ipswich was unchanged enough then for the places where Gainsborough had painted when he lived in the town to be still recognisable and the delight of Frost's life was finding these and working from them himself. Constable found the associations of Gainsborough and Ipswich so strong that on a later visit he could say "I see G. in every hedge". Not many would now immediately think of artistic inspiration when confronted by Ipswich but at that time it presented a most pleasant aspect, its wind mills on Stoke hills and the busy river traffic echoing Constable's home environment but with added excitement. He accompanied Frost on sketching jaunts around the town and its surroundings and they must have

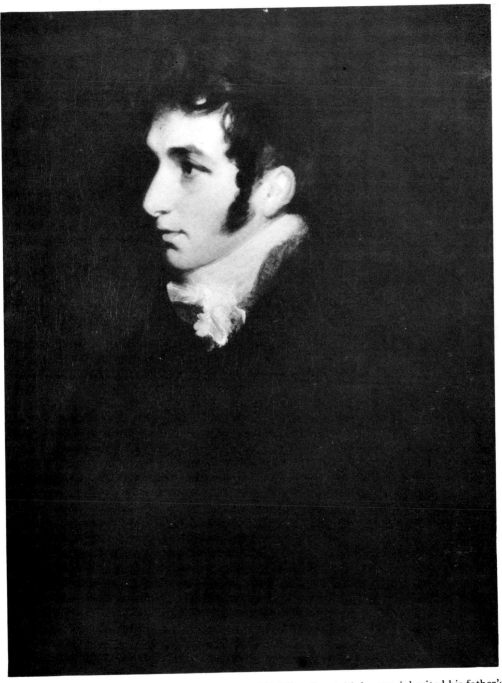

Abram Constable (1783-1862), the youngest of Golding Constable's sons, inherited his father's business capacities.
Christchurch Mansion, Ipswich *Oil on canvas* *74 x 61 cm.*

found fine views for working on if Cobbett's description is anything to go by, "The windmills on the hills in the vicinage are so numerous that I counted, no less than seventeen. They are all painted or washed white; the sails are black; it was a fine morning, the wind was brisk, and their twirling altogether, added greatly to the beauty of the scene, which, having the broad and beautiful arm of the sea on the one hand, and the fields and meadows, studded with farmhouses, on the other, appeared to me the most beautiful sight of the kind I had ever beheld."

By setting off and drawing in front of the chosen view Constable was again learning what Dunthorne had taught him, to look at what is in front of the eye and convey it as honestly as possible, without losing artistic purpose, on to paper or canvas. A recently discovered drawing by Frost provides a fascinating chance to compare two talents, he and Constable must have sat side by side to take the view of Ipswich docks, but how differently on that day, 5th October, 1803, they interpreted what they saw. The Frost remains a pleasant drawing, he takes no risks, does not bend the scene to his pictorial needs in the way Constable did. Still at an undeveloped stage in his career he had already outgrown his old friend although in the early days before he went to study in London he learnt a great deal from George Frost.

That the young man could move easily from the society of aristocracy at Dedham to that of the humble clerk in Ipswich is very indicative of a natural ability he had. An easy manner won him acceptance in whatever class of situation he found himself. Leslie described him at this time, "He was remarkable among the young men of the village for muscular strength, and being tall and well formed, with good features, a fresh complexion, and fine dark eyes, his white coat and hat were not unbecoming to him, and he was called in the neighbourhood the 'handsome miller'". He also had that quality which made his presence tell and which was to win him friends and enemies in his professional life with equal ease.

In 1796 Constable's horizon was further widened by a visit to London, probably connected with the family business. While staying with his maternal aunt and her husband Thomas Allen at Edmonton he was introduced into the circle of friends there who shared artistic, literary and antiquarian interests and met John Smith, later known as "Antiquity" Smith. In him another facet of the art world was revealed to Constable, between the rare world of Beaumont and the humble amateur of the country as represented by Dunthorne and Frost he could now place the tough professional and see the hard work and sharp wits needed to survive in such a career. The sheer fact of being professional must have had a glamour to it, although Smith was hardly the greatest exponent of the profession Constable might have met. Born in a hackney coach, he worked at mezzotint engraving and etching, wrote a biography of Nollekins the sculptor and would publish a book *Antiquities of London and its Environs,* which gave him his

nickname, and even become Keeper of Prints in the British Museum. In 1796 he was employed as a drawing master at Edmonton. Constable took up the friendship with youthful enthusiasm and Smith was probably flattered by so much admiration, he was helpful in sending painting materials out to Suffolk and even some plaster casts which were carried on the Constable ship *The Telegraph*. The largest box fell overboard and the keen young artist had to spend two days repairing the broken figures.

Smith was at this time engaged upon a book *Remarks on Rural Scenery* and Constable drew some Suffolk cottages in the hope that they might prove useful to his hero for etching as illustrations. They were not used but they are now among the earliest known drawings by him to have survived. At Edmonton Smith had introduced Constable to another painter friend, John Cranch, a Devon man who produced small genre pictures of country life and had a special liking for cottage interiors.

Cranch was of immediate use to Constable's art for he made out a reading list of essential books and gave him much good advice which found response with

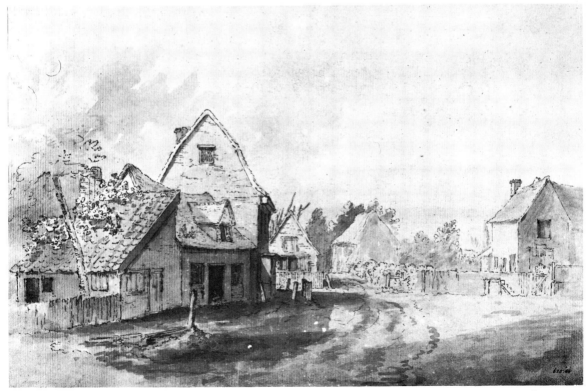

East Bergholt Street. An early drawing made c1796-9. Later, in 1802 Constable bought one of the cottages on the left for use as a studio.

Victoria and Albert Museum *Pen and watercolour* *19.5 x 32 cm.*

his forming beliefs. For example, Cranch, while recommending Sir Joshua Reynolds' *Discources* advises, "The Discources are a work of unquestionable genius, but they go, if I may so express it, to establish an *aristocracy in painting:* they betray, and I believe have betrayed, many students into a contempt of everything but *grandeur* and Michaelangelo". He also recommends the study of both the works of the great masters in original or print form and also, "The works of bad painters may be highly usefull, where truth and falsehoods may be ascertained through comparison with good pictures and Nature," and, "Nature herself, as divested and distinguished from all accident." Cranch was a modest painter but he and Smith represented much to the aspiring artist who returned to his home and work full of drive and resolution, soon he painted his first recorded oil, "a small moonlight in the manner or style of Cranch".

Constable's great genius was slow to appear and these early works gave no hint of what was to come, so it is not surprising that when asked for advice regarding Art as a career Smith recommended that he stay where he was. The next two years were the most difficult of his life so far, for he now wanted to paint full time but family and friends urged him to follow in his father's footsteps. He continued to work in Golding's office but was constantly tantalised by seeing what he wanted to paint, his memories from that careless childhood needed to be expressed through what he was learning. Ambition and knowledge were telling him that groping along painting in his spare time was not enough. There must been some awkward family situations, although he was ever an obedient son, and one wonders if he would have broken away and gone to London without his father's permission. Beneath his gentle manner he had one of his father's attributes, "the resolution of a Constable", and finally in March 1799 he was admitted as a probationer at the Royal Academy at Somerset House in the Strand, Golding having given him a small allowance on which to live while studying.

By this time Abram had probably left school and could take his place beside Golding but his parents must have had strong misgivings when they sent John off to London. The position of the artist was not respectable, and this attribute was highly necessary to such a family in country society. If he did not come to his senses and return home at best they could hope that he would become a portrait painter for this would bring financial reward and a respected place in society. Professional artists were not gentlemen unless they achieved acclaim through the Academy and this was to be done by portrait or historical painting. Landscape did not have any place in such a scheme so worry piled on worry for the anxious parents left in East Bergholt when John Constable set off on the coach for London. He was twenty-three years old and made long visits to his old home throughout his life but he was never to live there again, yet, stored within his artistic subconscious, he held the essence of the valley which was to give him inspiration for a lifetime and become known as Constable Country.

The Chymist and *The Alchymist* were inspired by the description of an apothecary's shop in *Romeo and Juliet.* Constable painted them in 1797 when he was trying out what he had learned from his London friends John Cranch and Antiquity Smith.

Private collection *Oil on panels* *20 x 19 cm. Copyright reserved by owner*

CHAPTER TWO

"We see nothing till we truly understand it."

John Constable

LONDON must have been a heady and exhilarating experience for John Constable just arrived in the capital from the country, with a place in the Royal Academy Schools and the freedom to make his own trial and error in the profession he so desired. Previous journeys to London had been connected with his father's business or family visits to his mother's relations and both had shown him the sober world of the merchants and the City. Now he saw fashionable, glittering living-off-its-wits West End London. Nothing could have been further from his character than this sort of life but the atmosphere must have excited him, free from his family for the first time.

His home background could well be described by the term "old court", used then to imply anything which dwelt on the solid if unexciting values and virtues as represented by George III and his staid and thrifty court. The Prince of Wales on attaining his majority had followed the traditional rôle of the King's heir, that of opposition to his father, and had set himself up in London where he lived in grand style while the King lived quietly at Windsor. While George III still held actual power and exercised it on all the duller aspects of governing which his approaching madness allowed, the Prince was free to enjoy all the more amusing privileges his position could provide and London threw itself in with a will to enjoy life with him. An arbiter of taste to the younger part of society, the extravagances and eccentricities he indulged were reflected throughout the period and have given it an unmistakable flavour. The confidence with which the Prince spent money or ran up debts on lavish entertaining and building projects gave fashionable London amusement, but he was not the widespread popular hero and dominating figure in the country as a whole. The French Revolution had caused tremors in England, here was its next monarch spending money he did not own when fear and hunger lurked beneath the surface of society. After the Revolution began the British establishment, and even the King, had welcomed it but as it progressed into the Reign of Terror feeling, even amongst the Radicals, turned against it. Patriotism became the order of the day. Coming at this time of his life, when he was just leaving school and taking his place in the world it had reinforced Constable's natural inclination and remained with him all his life. By the time he went to London the international situation was reshaping. Now Napoleon was striding across Europe but the Prince of Wales was more interested in creating the latest fashion than preparing to meet the problems of uneasy peace and the threat of war and invasion. Probably because of this uncertainty it was an age which

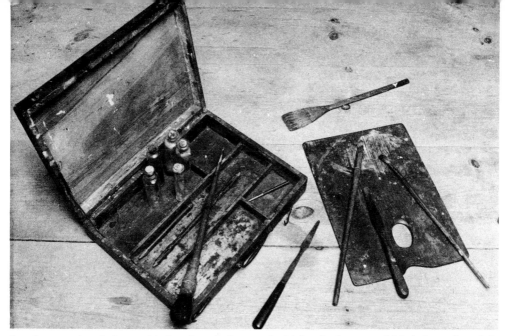

A palette and paintbox with brushes, knives and phials of pigment which belonged to John Constable.

Family collection.

tended to overact, and the theatre itself was never so popular. The Regency technically dates from 1811 to 1820 but it cannot be held within those confines; style, so important in every aspect of life then was already being established when Constable began his life in London. The very word Regency now evokes nostalgia for a time of reckless elegance, romance and a gay life set apart from the humdrum business of making money for survival. The theatre, sports and gambling of every description, gossip in the coffee houses, balls and soirées were what interested London and it concentrated on enjoying them with a will.

The art world did not reflect much of this, it was conservative and somewhat enclosed upon itself. The Royal Academy held sway, there were no public galleries or exhibitions for artists to show their work to the growing middle class who were acquiring a little culture with their mounting wealth and power. To win recognition a painter had to have the approval of the Academy and the support of patrons who were still largely drawn from the aristocracy.

Constable was fortunate, he had been accepted as a student at the Academy schools so was on the right road to approach the exhibitions, and he had an introduction to Joseph Farington, a highly important figure in the London art world. Farington's painting is forgotten now but his diary, which he kept most comprehensively over many years, has earned him a unique place as chronicler of his times. He was in the perfect position at the centre of things, for he knew the successful to whom he was friend and confidant and was equally helpful to the

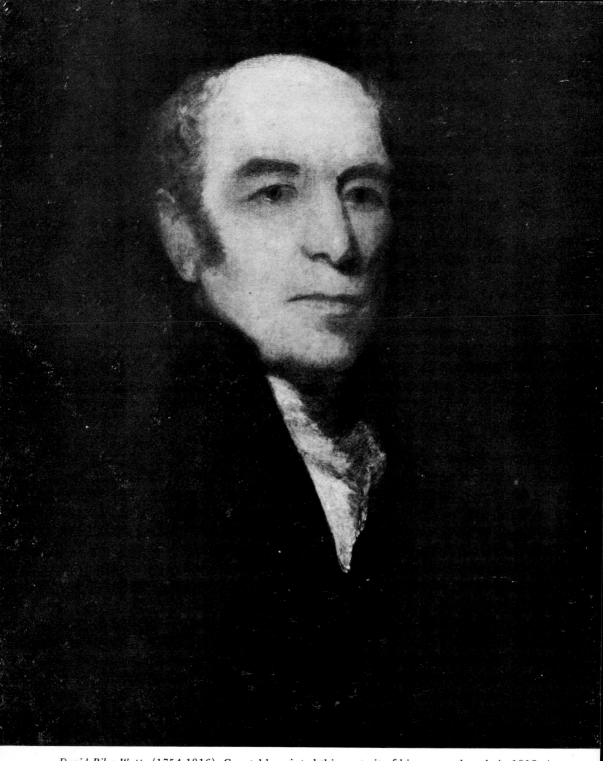

David Pike Watts (1754-1816). Constable painted this portrait of his maternal uncle in 1812. A wealthy wine merchant, Pike Watts gave his nephew much help during his early years in London although he could be overbearing in his artistic opinions.

Family collection *Oil on canvas* *63 x 50.5 cm.*

young and struggling. Everyone went to him and his power as an *éminence gris* was considerable. To Constable he was a life-long friend and guide.

A fellow student was also an immediate friend although it was not to be a lasting relationship. Ramsey Reinagle, who painted Constable's portrait at this time, was the son of a picture dealer and his interest in making a business out of art gradually overcame his painting. For the moment he and Constable shared rooms together but the difference in their characters was soon telling. Constable would have nothing to do with supplying to order facile pictures to satisfy business demands nor was he the man-about-town type his friend represented, ready and willing to dabble in all sorts of dealing. Although he did buy a share in a painting by Ruysdael which interested him artistically before Ramsey Reinagle, following his father's trade, whisked it off and exchanged it for other pictures which he hoped to sell.

For students the study and copying of other men's work was an essential part of their training. When they could afford them they bought paintings, drawings and prints which were built up into a personal reference library as illustrations in the art books published were few and then subservient to the text. Some artists, like Thomas Lawrence who was said to have spent £70,000 on drawings by old masters, amassed great collections, others bought what they could. In Constable's case he would spend money which should have bought his next meal on a print, drawing or book. His incongruous position probably became clear to him very quickly, for, just as at home he was an odd man out because of his ungentlemanly desire to be a professional artist, among the artists of London, who invariably came from the lower classes, he was an outsider because he was a gentleman from the middle class.

To start with his convictions about art had to be held in check a little because he had to work his way through the Academy schools to prove to his family that his talents were of worth and to make up for the deficiencies which being an amateur in the country had caused in his painting. He worked hard at Life classes, anatomy lessons caught his enthusiasm and he set about the inevitable copying with a will. Although Sir Joshua Reynolds, the great man of the Academy whose influence still lingered after his death, had said to the young Lawrence in 1786, "It is clear you have been looking at old masters; but my advice to you is to study nature; apply your talents to nature, and don't copy paintings" the practise was still considered essential to every student's training. Constable followed the tradition, for all his belief in studying nature firsthand he was aware of the continuity of art and was later to say, "A *self-taught artist* is a very ignorant person." Having the friendship of Beaumont was of great use to him, as not only did he allow artists access to his collection but introduced those he favoured to other collectors who allowed copying of their masterpieces. Indeed there was even a market for copies and owners of portraits, especially, often commissioned copies of these for hanging

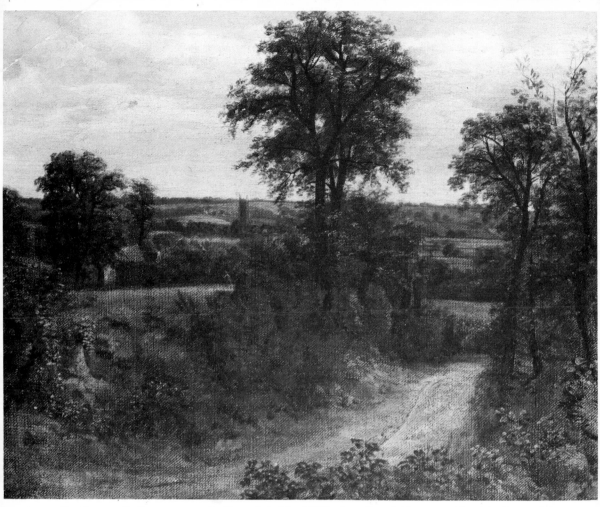

Road near Dedham was probably painted in 1802 when Constable was taking his first major steps towards a natural artistic expression of his native countryside.

From the collection of Mr and Mrs Paul Mellon *Oil on canvas* *33.5 x 41.5 cm.*

in another house or giving to members of their families. Constable himself was to earn part of his living shortly by doing just this sort of work for the Dysart family. It may not have been what he wished but he learnt much from these pictures, which were by Reynolds, that was of service to him in his own taking of portraits.

The student's life was undoubtedly hard work as the hours at the Academy were long, classes going on into the evening and artists could not rely on large firms placing ranges of ready prepared paints and frames easily at their disposal. A number of colourmen supplied and mixed pigments and the better established artists employed assistants to prepare the pigments and media ready for their use, make stretchers and apply the canvas. But most had to spend valuable time mixing

and preparing for themselves. Many small frame shops existed but the cost of having a frame made for a specific picture was extremely high and when works were sold the price often did not include the frame which the artist kept for his next production.

When not working in the Academy some found employment colouring prints and drawings for dealers in the evenings, others gathered in the coffee houses to discuss and argue over the politics of the Academy, others enjoyed the pleasures London could offer. It seems unlikely that the brash, frequently cruel pastimes which entertained Londoners, rat pits, gambling clubs or the numerous theatres where the 'Fashionable Impures' displayed themselves found an enthusiast in John Constable. He did enjoy a play, but went very infrequently, and gambling had no place in his character, the disorder of the dark city at night where oil lamps made deep shadows for every sort of crime would have repelled him. He must often have longed for home but he did have family contacts in London; his sister Martha had married Nathaniel Whalley, the son of a prosperous cheese merchant, and was living in the City and there was the support of his maternal uncle, David Pike Watts.

This man had become a very rich wine merchant and could be taken as a perfect example of the rising middle class. From typical quiet City beginnings he had prospered sufficiently to take a house in Portland Place, entertain prominent artists and architects, buy himself a country seat in the Lake District — from which he soon returned for he was a thorough city man — and buy amongst other works for his collection Gainsborough's *Cornard Wood*. He received his nephew with approval for as he said, "J.C. is industrious in his profession, temperate in diet, plain in dress, frugal in expenses, and in his professional character has great merit." Pike Watts could be thoroughly irritating and interfering with his pious attitudes and conviction that his opinions on art were of the best for a young artist to follow but he made up for this by being of real help to Constable. Lifts in his carriage, dinners and introductions, gifts of books and prints and the purchase of paintings all helped his nephew in addition to providing a tangible link with home. From Suffolk baskets of food arrived by the Constable boat and reg-

A Bomb Ketch sketched during Constable's voyage from London to Deal in 1803. Despite its small dimensions it is full of energy and movement.

Family collection *Ink* *6 x 7.5 cm.*

ular letters from his mother worrying over his health, eating habits and staying up too late, kept him in touch but still Constable missed the country and the quiet solid background of village life. He wrote to Dunthorne, "I even love every stile and stump, and every lane in the village, so deep rooted are early impressions". And oppressed by the metropolis he reported, "I paint by all the daylight we have, and that is little enough, less perhaps than you have by much, I sometimes however see the sky, but imagine to yourself how a purl must look through a burnt glass. All the evening I employ in making drawings, and reading, & I hope to clear my rent by the former."

On early trips home he took Reinagle with him, but he was soon to be disillusioned by the acquaintances he had made among fellow students and artists and it was again to Dunthorne he confided that he was disgusted "with their cold trumpery stuff. The more canvas they cover, the more they discover their ignorance and total want of feeling". This is hardly surprising, for he had already formed his own innocent ambitions before going to London and finding his beliefs in exact opposition to what was required of artists was facing disappointment, frustration and the artistic loneliness which was to dog him all his life.

Patrons wanted portraits of themselves and families, historical extravaganzas or landscape with strong Italianate overtones with classical nymphs added. The major event of the year was the Academy exhibition which opened in May, but the growing art-buying public was still relying on the taste of the great collectors of the eighteenth century who made the Grand Tour and brought back many works of classical landscape with them. And Constable could see amongst exhibitors and public that no market existed for someone who painted the ordinary life of his native countryside, but his resolution remained firm and even in the Academy he found an unusual ally. One of the models, Sam Strowger, was a Suffolk ploughman who had gone into the Life Guards. As the Academy chose its models from these troops Sam's symmetrical figure and steadfast character soon singled him out for attention, his discharge was procured and he was made model and head porter at Somerset House where he was a thoroughly biased supporter of Constable's work and commented on the accuracy which was to be found in his fellow countryman's paintings. Agricultural accuracy was not a quality to achieve fame and success in a period which wanted either classicism or the wilder attributes of stirring Romanticism.

The Suffolk artist found another sympathetic friend in Benjamin West, the president of the Royal Academy, who is said to have demonstrated on a rejected painting of Flatford Mill the necessity of chiaroscuro. "Always remember sir, that light and shadow never stand still," advice well in tune with Constable's own ideas, and "Whatever object you are painting, keep in mind its prevailing character rather than its accidental appearance (unless in the subject there is some peculiar reason for the latter), and never be content until you have transferred that to your

canvas. In your skies for instance aim at brightness, although there are states of atmosphere in which the sky itself is not bright, I do not mean that you are not to paint solemn or lowering skies but even in the darkest effects there should be brightness. Your darks should look like the darks of silver, not of lead or slate." All good advice which Constable took to heart and reinforced his own feelings. West was a figure of some controversy in the Academy, having been placed there by the king against the academicians' wishes but he was helpful to Constable in other matters as well as chiaroscuro. In Suffolk Constable had been introduced to Dr John Fisher, later Bishop of Salisbury, who, seeking to help a struggling young painter of good family had procured for him the offer of a post as drawing master in a school. Fortunately West's advice prevailed and he helped Constable refuse the job for he fully realised that teaching "would have been the death-blow to all my prospects of perfection in the art I love."

At Chatham in 1803 Constable viewed the fleet lying there. This *Two Decker Man O'War* is one of the many drawings he made.

Family collection *Pencil* *18 x 25 cm.*

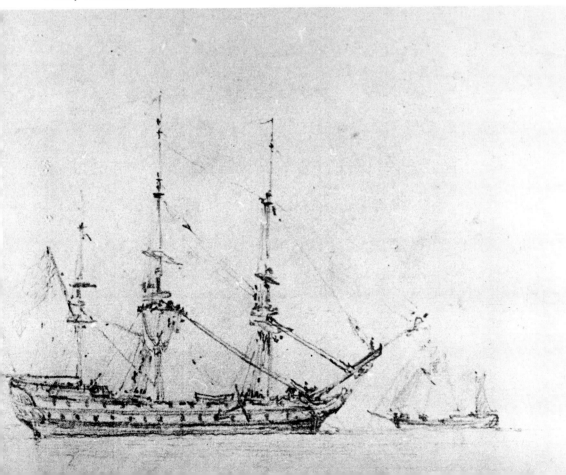

A trip to Derbyshire in 1801 had given him a sight of a different landscape from that he knew inside out and the work he did there shows the confidence and freedom his London experience was giving him. It was probably on this visit that he first met Wordsworth, the poet with whom his paintings are often linked as the perfect expression of the English genius. They never became friends, Constable felt that Wordsworth held too high an opinion of himself, but both were patronised by Sir George Beaumont so their paths crossed several times in later years. Constable painted hard in the North but it was to his own country that he looked for his future and after escaping the teaching job he went down to East Bergholt that summer with added drive and determination regretting "these past two years I have been running after pictures and seeking truth secondhand," but planning to "make some laborious studies from nature — and I shall endeavour to get a pure and unaffected representation of the scenes that may employ me with respect to Colour particularly". That year saw his first dated picture in which he is almost himself — the *Dedham Vale* in the Victoria and Albert Museum. It lacks the force and sureness of hand which time and maturity would give him but it is "a Constable".

At what time he became conscious that an enthusiasm, a deep rooted love and delight was not enough, we do not know. But to grasp the intrinsic truth of nature and to liberate it through his art and then grasp it again and form it into his own personal expression of art was slowly becoming his aim. Sometimes he referred to himself when at home in Suffolk as a cock in his own yard. As he painted he came to know that to stand tall and crow at the glory of the morning was not enough, being a man and not a cockerel he had an obsessive desire to capture the beauty of the morning but also discover the truth of it. To see more clearly into the nature of his own response to that truth, and from it create art. It is for anyone a daunting task, a lifetime of exertion and search. Constable was what is called in facile language "a late developer" and the next few years saw him valiantly working forward inch by inch, never ceasing to put everything he had into the effort but not really making a major work of art until the frustration and disappointment he encountered during the courtship of his future wife forced him to plunge to the heart of his impressions and find the secrets of himself and the subjects he was painting.

With the end of his student years he was a little nearer to being able to paint those dream pictures from his childhood but he was also faced by the necessity of earning a living. An artist could make an impression on collectors by working on topographical views of the beauty spots of Britain which had gained favour since the Napoleonic wars had made the European tour impossible, but such work was not part of Constable's inclinations. In Derbyshire and a later trip he made to stay with the Whalley family in 1806 he visited all the renowned areas but the barren land and empty space, however grand, showed no form of human contact or scale

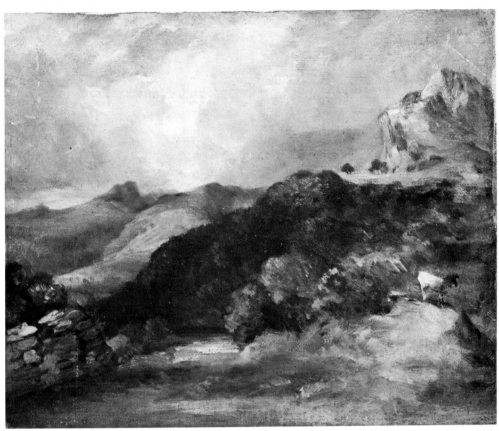

On a trip to the Lake District in the autumn of 1806 Constable diligently worked at taking the views he saw, like this sketch made of *Bowfell and Langdale Pikes*, but the solitude of the mountains oppressed his spirits.

Family collection　　　　　*Oil on canvas*　　　　　*20.9 x 25.5 cm.*

Another sketch made in 1806. This has been squared -up for enlarging onto a canvas.

Family collection　　　　　*Watercolour*　　　　　*19.5 x 37.5 cm.*

and he admitted that the solitude of the mountains oppressed his spirits. A glimpse of his deep interest to come is seen in the trip he made in the spring of 1803 from London to Deal aboard the *Coutts,* an East Indiaman belonging to a friend of his father. This voyage gave him a month on board ship during which time he observed "all sorts of weather" and at Chatham viewed the men of war lying there in great numbers. Hiring a boat he was rowed round the fleet and was able to make a number of sketches including one of the *Victory,* "very beautiful, fresh out of dock and newly painted". She had yet to achieve immortality as Trafalgar was still to come, in 1805, but from the sketches he made the finished drawing of the *Victory* as she might have appeared during that battle which he showed at the Academy exhibition of 1806.

Studies of changing weather were as unlikely to earn his living as were views of his father's mill so he set to work copying and making portraits; a number of these were of local worthies in Suffolk and here other commissions came his way. The family were very pleased at the honour when he was asked to paint an altar-piece for Brantham Church. Although it proves his lack of talent in this field of painting his parents were reassured as to his growing position as a painter and probably to their devout sensibilities it was even better to be a respected painter of holy decorations than a respected portrait painter. In time he accepted two other such commissions, that for Stoke by Nayland and a third painted for Manningtree, but which is now at Feering in Essex.

These first few years of Constable's professional life lack the cohesion he was to find after 1809. He worked hard, took an active part in London art affairs, went home to Suffolk each summer where he continued to see pictures in his beloved valley but his ideas were still unacceptable in art circles. Opportunity for exhibiting had increased by the formation of the British Institution, a body of subscribers which included Beaumont, who from 1805 presented exhibitions of loaned works by the great masters such as Rubens and Claude in rooms in Pall Mall. Perhaps what is more important is that they also aimed at supporting living artists and held open exhibitions of their work. By accepting modern works these men of the British Institution were setting another thread in the fabric of 'taste' which was rapidly assuming enormous importance. As the wars with Napoleon created wealth for the middle class they had to emulate the aristocracy and its established traditions as a mark of cultural distinction. The aristocrat of the eighteenth century had worked out his own salvation in interpreting those essentials of life, the Sublime and the Picturesque. The new public had to be given instructions as to the correct path to follow so that there arose a great craze for defining the principles of taste, in particular through architecture and landscape.

In architecture the period has left some of the most elegant building from this country's history but even then owners were constantly trying to make

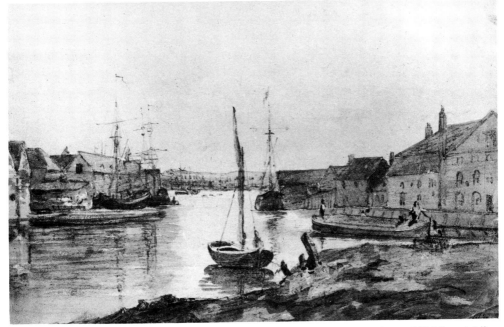

Warehouses and Shipping on the Orwell at Ipswich. Constable noted "5 Oct — 1803 Ipswich" on back of this drawing. It shows how far, although still searching for his fullest potential, Constable had surpassed his old friend George Frost.

Victoria and Albert Museum　　　　*Pencil and watercolour*　　　　*14.5 x 33 cm.*

A recently discovered George Frost. The two friends must have made these two drawings side by side but the Frost is pedestrian when compared to the Constable.

Stanhope Shelton collection　　　　*Watercolour*　　　　*19 x 30 cm.*

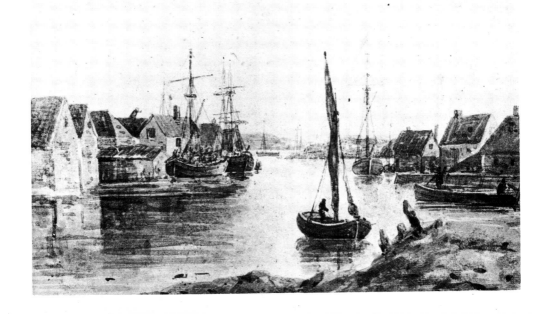

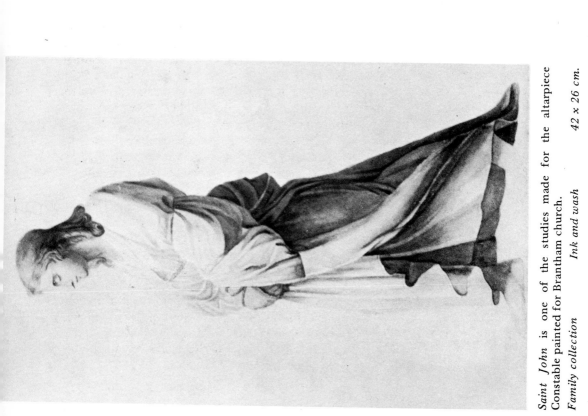

Mary Constable in a Red Cloak. Constable's younger sister painted a little herself and became somewhat eccentric in old age.
Family collection *31.5 x 16.5 cm.*
Oil on millboard

Saint John is one of the studies made for the altarpiece Constable painted for Brantham church.
Family collection *42 x 26 cm.*
Ink and wash

picturesque "improvements" to it. The graceful cottage or villa which was being built in towns all over the country and in groups around the more genteel parts of London's edge were decorated with motifs from Greece or the Orient. But it was landscape which really gave scope to the arbiters of taste. Richard Payne Knight, one of the most influential and vocal, defined scenery as falling into three types. "Classical" which should have associations of "fallen magnificence", "Romantic", "in which every object is wild, abrupt and fantastic" and "Pastoral" which consisted of "neat, comfortable cottages, inhabited by a plain and simple, but not rude or vulgar peasantry; placed amid cultivated but not ornamented gardens". In common with others in the agricultural community Constable did not welcome those who "improved" the countryside whenever they could get their hands on it. Having made their house and garden harmonize the *nouveau riche* who were moving out of the cities and acquiring property in the country turned their eyes over their fences and planned how to incorporate the rest of nature into their own designs. Luxuriance was one of the watchwords of the planner. Creepers, shrubs and overhanging branches were necessary to "mantle luxuriantly over the windows" although they had to be kept in careful check for if they got round and solid they became "rather injurious in a Picturesque light". Man also came into the grand plan but only in so far as he was harmonious with the rest of nature and the owner's idea of it.

A few years later when John Nash was planning his "landscape for living in" he made the canal across Regent's Park because the bargees would "enliven" the scene. Not everyone could work on this scale except those rich eccentrics like William Beckford who built Fonthill, a habitable ruin, or the Earl of Shrewsbury who, at his seat Alton Towers, kept a blind harpist in a "rustic" cottage and used stucco sheep to "enliven" the scene. His improvements on nature are worth quoting in full for they sum up what the public sought in landscape and what John Constable did not think worthy of his paintings. A valley on the Earl's estate after being "improved" contained "a labyrinth of terraces, walls, trellis work, arbours, vases, statues, stone stairs, wooden stairs, turf stairs, pavements, gravel and grass walks, ornamental buildings, bridges, porticos, temples, pagodas, gates, iron railings, parterres, jets, ponds, streams, seats, fountains, caves, flower baskets, waterfalls, rocks, cottages, trees, shrubs, beds of flowers, ivied walls, rockwork, shellwork, rootwork, moss houses, old trunks of trees, entire dead trees etc."

How such a collection would have offended Constable's sensibility! Nature as god had made her, unadorned but ennobled by partnership with man in his work was more to his taste — but not to the taste of the public, so his landscapes remained unsold. They gave no viewer the 'restrained terror' of the Sublime nor the 'mournful pleasure' of the Picturesque. In the circulating libraries the Gothick tale was all the rage and the public learned to criticise in literary terms those features of nature which should excite their admiration. Ruins which could be both "awful" and "soothing" featured high on the list and there was an unceasing

interest in death. Only in one picture, and that not painted until 1835 did Constable show anything so fashionable. This was *The Cenotaph* made from drawings taken in the grounds of Beaumont's estate where he had followed the fashion for placing monuments about, a boulder was inscribed and dedicated to Richard Wilson, and this cenotaph was raised to honour Sir Joshua Reynolds, who was always held in the highest regard by Constable.

To the dedicated artist it was frustrating in the extreme to hear all the controversy raging in London — for its participants took their analytical enquiries into taste very seriously — and finding his own convictions rejected even by his friends. We now place Constable with his contemporaries — the radical reformer Cobbett, and Wordsworth (though he would not have approved of such company) — in typifying the movement which aimed at showing the English their own country for the first time, in showing its value above being a provider of food, an element in which all life had a place, but in his time his ideas were unacceptable.

He did, in fact, find one sympathetic friend, perhaps they had met through David Pike Watts, and this was a fellow East Anglian, William Crotch. He had been an infant musical prodigy and while still a child had left his Norwich home to become Professor of Music at Oxford. There he had been encouraged to paint and draw by Johann Malchair who led the Music Room orchestra and also figured prominently in a group of amateur painters who called themselves "The Great School". Malchair was president of the society which had included in its time such men as Sir George Beaumont. Crotch and Constable had much to talk of in addition to music. Malchair had taught Crotch to walk about and study his subject from every possible angle and level before settling down to make a drawing. "Forty different pictures are produced from the same subject in an hour," he had said and Crotch worked with this in mind, even noting details of day, date and location on the backs of his drawings.

To find his own ideas supported from another source was a comfort and encouragement to Constable and although the friendship may not have been on really intimate terms there was a common interest in music and sympathy towards the same aims in painting which ensured that it continued during the next thirty years. Constable is even recorded as painting a scene for an amateur production of *Henry V* in which Crotch performed in 1812.

The uncertainties of the war with France made life even more precarious than it ever is for an artist, but it was a period of growth and prosperity for agriculture and Constable's summers spent at East Bergholt were a haven, still secure, family and friends believing in him even if they did not understand what he was trying to do. Local families patronised him as portrait painter, Dunthorne was there to help with studio work in the cottage almost opposite East Bergholt House which Constable had bought in 1802 to use for working in, and provide a

ready ear to his theories and hear all the London happenings. The country awaited him, as enticing as ever, the martins still swooped over the mill pond and there was the quiet social round of old friends when he could be persuaded to rest from painting. Why then did he not return to live in Suffolk? Golding offered him a house in Dedham, but having suffered the defeats and insults of the London art world he had been given the stimulus to show his opponents the true worth of his art. Only honour in the Royal Academy and public recognition of his painting would satisfy. Had he gone back to live in the country, painting portraits and taking the local views, he would have lost the impetus that London competition gave him. His ambition would have become harder to sustain, the momentum gradually becoming less. If he had done so he might never have achieved anything and his valley might never become synonymous with him, only by not living there could he create from it.

During these years he met as a matter of course the family of the rector of East Bergholt, Dr Rhudde, when they came to stay at the Rectory. As a mature young gentleman from a most respected family he was a favoured companion for the rector's grand-daughters when they took walks in the country or attended evening gatherings in the houses round about. In 1809 John Constable knew he was in love with one of these girls he had known since their early childhood, Maria Bicknell, who was then grown up and aged twenty-one. Constable was thirty-two. The difference in their ages had at first put them in different generations but as Maria grew up they found more in common than the passing social manners of their society. Like all well brought up young ladies she attempted a little sketching and this gave them further opportunity to be together. She even took a view of Flatford Mill which was already so much a part of Constable's work that his passion for painting and drawing it had become a joke between them.

Maria was born on 15th January, 1788, the eldest child of five which were born to Charles Bicknell and his second wife, the daughter of Dr Rhudde. Her health was always delicate and this may have been the reason she had not married before reaching the age of twenty-one, which was later than many of her contemporaries who were settled with families of their own. Her father had been solicitor to the Admiralty and also to the Prince of Wales and his youngest and favourite sister Princess Amelia for some years, he held offices in various responsible positions and in 1815 he was nominated by the Prince Regent to be one of the committee of three who took over the private parks and forests of George III. He was thus able to give his family a life of comfort and position. It was a quiet life, however, for he did not join in the frivolities of the court despite his close connections, he was rather one of those men who ensure that everything runs along smoothly while everyone else enjoys the party. A house in Spring Garden Terrace gave the family a good address where Maria often had to take command when her mother's health made her an invalid.

Before declaring himself Constable may have taken a long hard look at his life and his prospects but prudence was not one of his virtues and his confidence in himself and his future would have been highest when in his own home setting; the fact that he was finding difficulty supporting himself on his allowance and his meagre earnings from portraiture did not seem so important when compared with the fact that he and Maria loved one another. He had lodgings at 63 Charlotte Street which gave him a painting room in addition to living rooms, and being in good health he could look forward to a future of rising fame and fortune. Good friends in the church and aristocracy thought highly of him and his family was as respectable and solvent as any prospective father-in-law could wish.

He blinded himself to the fact that Maria's delicate constitution needed care, she was used to a household where a number of servants were at her command and the ordered running of her life was essential in protecting her from ill health. He lived irregular hours, catching light for painting when it was right and available, he was notorious in his disregard of regular meal times, his food often cooked by the wife of the upholsterer downstairs from whom he rented his rooms.

Certainly he had good friends and connections in church and aristocracy but it was a very masculine world in which he moved. Would his wife be able to have a drawing room in which to receive, and what would be the position in society for the wife of a painter whose own position was rather odd? The artist was received by his aristocratic patrons, his art being his passport, but to receive wives put the whole thing on a different footing. Normally professional artists came from the lower classes so there was no question of receiving their wives, but Constable's own incongruous position made the possible status of his wife something of a problem. The style of Maria's life, her whole position in the society into which she had been born would change for the worse. Charles Bicknell was not an unkind man, he was in fact an undulgent but foolish father who wanted to please his daughter, but he must have reviewed all these doubts as to the success of the match. Unfortunately he was not able to put his feelings to the hopeful pair in straightforward fashion, for he was ever of dithering personality.

The matter was soon taken out of his hands for when Dr Rhudde realised the serious nature of the attachment between his grand-daughter and John Constable he denounced and forbade it and started off a most painful period in the artist's life.

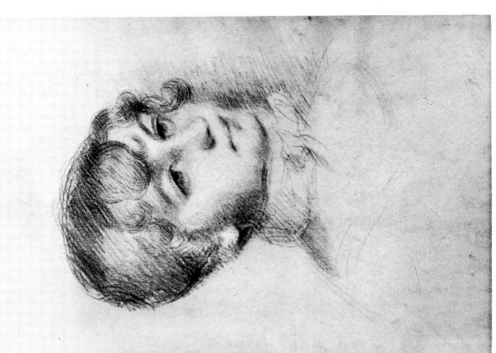

Maria Bicknell (1788-1829). Constable fell in love with her in 1809 although he had known her for several years through her childhood visits to her grandfather Dr Rhudde, the rector of East Bergholt.

Family collection Pencil 47 x 33 cm.

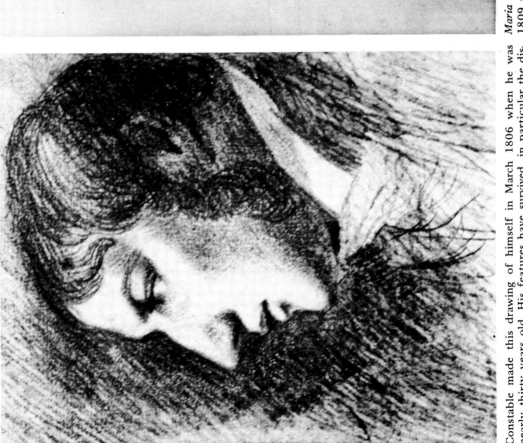

Constable made this drawing of himself in March 1806 when he was nearly thirty years old. His features have survived, in particular the distinctive nose, through many of his descendants.

Family collection Pencil 18.5 x 14 cm.

CHAPTER THREE

"The heart of the lover is never at rest,
With joy overwhelm'd, or with sorrow oppress'd."

William Cowper

HAVING threatened to leave his money to his younger daughter and her children rather than to Mrs Bicknell and hers Dr Rhudde was well satisfied. His character was as strong as Charles Bicknell's was weak and he could bully his son-in-law as he pleased. Just what were his objections to the marriage are not recorded specifically and indeed as time went on he himself seems to have become confused, but they were probably not just concerned with Maria's health and future happiness and security. His forceful character did not make him the most popular man in East Bergholt and he had violent quarrels with several of his parishioners, including Golding Constable. As shepherd of his flock he was worldly rather than humble, keeping two curates to attend to matters during his frequent jaunts to London where he owned a house on Stratton Street. His fortune was apparently inherited from his sister and her husband and included land at Newbourne and Felixstowe. Although probably not a great deal larger in value than Golding's assets he used his money differently. To stay in London he drove up in his own carriage, no small expense at a time when heavy taxes were levied on private vehicles. When he entertained it was in a grander style than the Constables maintained, and possibly most important of all, Constable wealth was founded on trade and Dr Rhudde had inherited his while spending his life in the church. There was the further irritation of John Constable's occupation and his friendship with John Dunthorne, the village atheist, with whom the rector was constantly on bad terms. All added together utterly to outrage the old man and, in order not to bring the whole venture to a violent and sudden end before it had hardly begun, the lovers had to agree to make no move and to let things proceed quietly for the time being. The events of the next seven years are confused, tragic, even ridiculous, but so extraordinary they are worth following step by step.

By 1811, when the Prince of Wales was made Regent, Maria was running her father's household because her mother's ill health had reduced her to an almost permanent invalid and the tuberculosis which was to decimate the family had already claimed the eldest son. Constable was permitted to visit Spring Garden Terrace and amiable relations were continuing as usual between the two families. Never renowned for his patience, he now felt that after two years they had waited long enough and that things should not be allowed to drift any longer. In her letters Maria constantly begged for prudence and he persistently refused to be prudent and begged her for the wedding date. Seeing unhappy times ahead because

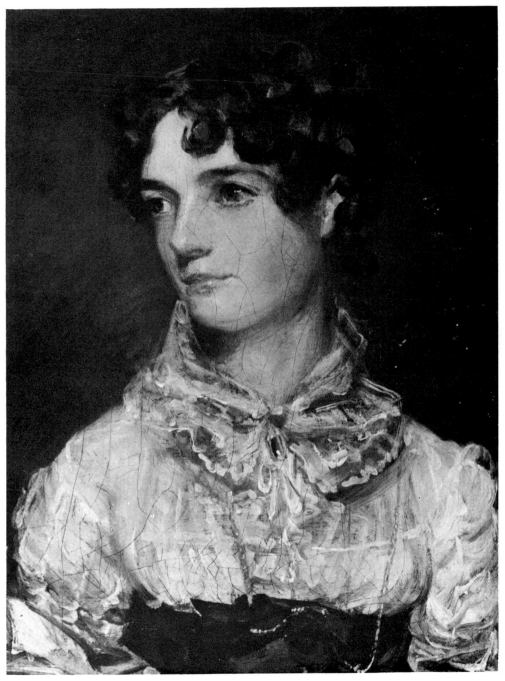

Maria Bicknell painted in 1816 by John Constable when their long and troubled courtship was nearly at an end.

The Tate Gallery, London *Oil on canvas* *29.8 x 25 cm.*

of the lack of cash, "we should both of us be bad subjects for poverty," she advised him to think of his painting — "it could not survive domestic worry".

On a visit to Salisbury Constable now met the man who was to become the most important friend in his life, John Fisher, the nephew of the Bishop of Salisbury who carried the same name and had been an early encouragement to the artist. John Fisher was much younger than Constable, he was the same age as Maria, but he was more in tune with the artist's forward looking ideas on art than his uncle and they immediately took to one another. Much as he welcomed this new friendship at the moment it was Maria who occupied Constable's thoughts.

Probably to place her out of his reach without causing a scene she was sent to stay with her stepsister Mrs Skey, the daughter of Charles Bicknell's first marriage and now a widow living in Worcestershire. Letters passed back and forth but London was empty and without meaning in her absence. And then Constable received a letter, written perhaps because of her feelings being swayed by the strain which was on her father, saying that only further unhappiness could be expected if they continued to write. This was too much for Constable, he immediately took the coach for Worcester and, arriving at Spring Grove in Bewdley where Mrs Skey lived, presented himself on the doorstep completely out of the blue and unannounced. This time his dash and resolution did not go unrewarded for he was well received, and after staying two days he returned to London happy in the knowledge that though she might advise prudence in her letters Maria's feelings were in accordance with his.

The new year came in and even Golding, who being a man of Suffolk did not waste his words, was moved to write to his son urging him to apply his energies to bettering his position before undertaking matrimony. But this was 1812, one of those years which have been called romantic in a pejorative sense, when reason and calm judgement were ignored and events became exaggerated. Napoleon was the chief romantic of the year as he first invaded and then retreated from Russia, the U.S.A. declared war on Britain and on 11th May Spencer Perceval, the only British Prime Minister to be assassinated, was shot in the lobby of the House of Commons. The assassin did not act from political motives but he was cheered on the way to the scaffold and there were many murmurings about the revolution to come and the general uncertainty led to the formation of a government which, by its savage legislation, became responsible for the discontent and riots which marred the late Regency period. In the arts and the fashionable world the note was set by Lord Byron who published *Childe Harold's Pilgrimage* in March.

To Constable all this was nothing. Maria returned to London briefly in January and he spent many hours loitering near her home and in St James' Park where she walked, in the hope of engineering what she wanted "that chance might effect the pleasure of a meeting without the pain of a premeditated appointment". St James' was still a place where Londoners walked to be seen as much as

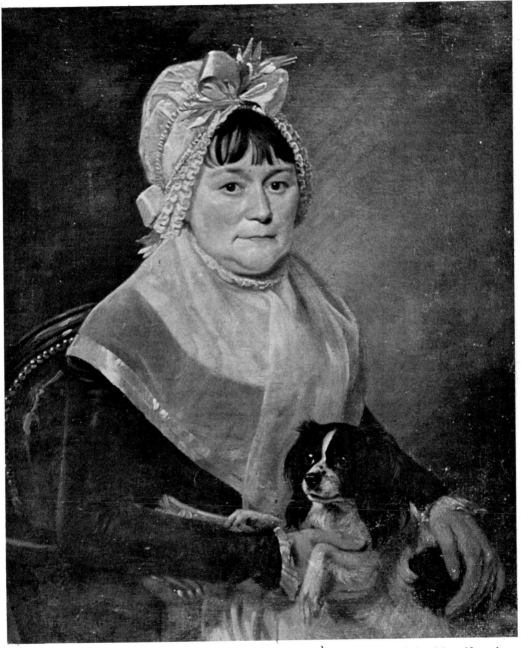

Ann Constable (1748-1815) painted by her son c1804 when he was applying himself to the painting of portraits as a means of earning his living.

Family Collection *Oil on canvas* *76 x 63.5 cm.*

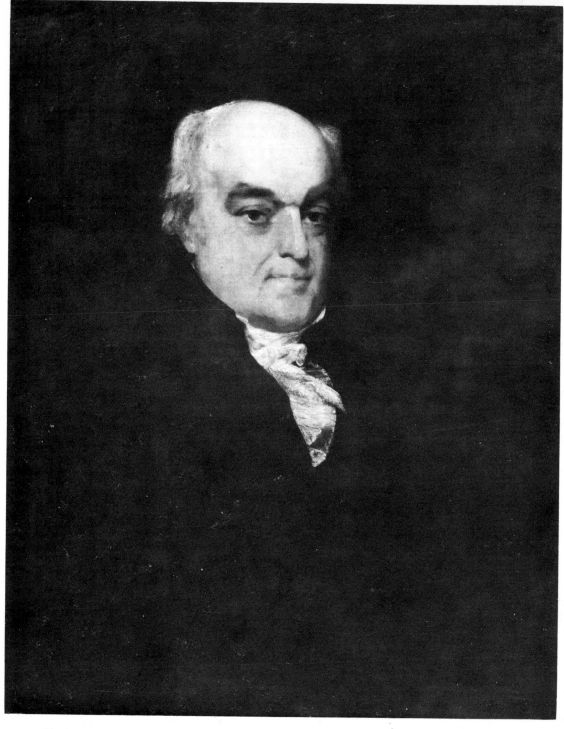

Charles Bicknell (1751-1828). Constable must have painted this portrait during the short period of his married life to Bicknell's eldest daughter.

Family collection *Oil on canvas* *77 x 67 cm.*

for their health and so much time did Constable spend on effecting the chance meeting that Maria, who was also feeling the strain of their situation, had to write to him before leaving for Spring Grove again. "How can you thus distress me and needlessly torment yourself," and she leaves him with words of good sense, "I trust I may have the satisfaction of knowing that you are steadfastly pursuing painting, and that you are building your faith upon a rock that will never be shaken, it is religion that should support you in every trial if you will trust to her.

Think my dear sir of the number of wasted hours spent in the Park, think what an unsettled being I am rendered. I should not love you if you did not feel my absence, but feel it as a Man, rejoice that I shall be acquiring health and that you will be getting on with a profession upon which so much depends." Good sense but poor comfort for the ardent lover and made even worse by the fact that his mother also took him to task: "Now my dear John, . . . do paint with energy and spirit — do not be supine — but work that you may obtain, when you know to what good account you can turn your gains."

This was always a difficult time of year, paintings had to be prepared for the Academy exhibition for which the sending-in days were in April. Short daylight hours and poor weather restricted painting time and depressed the spirits. Leslie deplored the time of year for painting, "when the strongest men get irritable and uncomfortable, during the prevalence of the Northeast winds, the great destruction of the frame of England". Appreciating her son's difficulties Mrs Constable now sent his sister Mary to stay with him at Charlotte Street. Mary was also interested in painting, but not more than was right for a young lady, yet her sensitive company did much to restore her brother so that he was soon able to write to Maria to say that he had managed to send four pictures to the Academy and was avoiding the park and its uncomfortable memories. Even better news was that he had left a card on Dr Rhudde who was in town and that the doctor had been very courteous and offered to convey any letters he wished to send to East Bergholt. Post was still extremely expensive and it was the accepted duty for everyone to offer to carry letters when travelling. But that he should be so received by the old man who was his enemy shows what a surface of manners could be grown over any social wound. During the next two years the two families could technically be described as at war, but politeness never deserted either side.

Wishing to improve his standing as a provider Constable now applied himself to portrait painting which would earn him an income. First he painted Uncle Pike Watts and then set about copying portraits for Lady Heathcote and Lady Louisa Manners. Unexciting tasks, but they would improve his finances. When June came he went down to East Bergholt where, although he enjoyed walking with the family dogs, he did not neglect the pressing subject of his income. The favourable reception given to a portrait of William Godfrey, younger son of Peter Godfrey, the squire of the village, led to an invitation to visit Wivenhoe Park to paint the

East Bergholt Church, the imposing centrepiece of his native village, appeared in a number of
Constable's works. This airy sketch, taken from the lane leading down to Flatford, was made
during one of his hard working summers in Suffolk 1810-1815.

Family collection *Oil on canvas* *18.8 x 16 cm.*

The view of East Bergholt Church looks much the same today as it does in Constable's oil sketch.
Col. C. A. Brooks

likeness of the young daughter of General and Mrs Rebow. There was never much of the holiday about these visits home; when not working on the portraits he worked even harder on landscape painting and this summer kept up a continuous correspondence with Maria who went to Bognor with Mrs Skey.

They exchanged views on the controversy over Taste, agreed on the virtue of William Cowper, then thought of more for his religious writings than as a poet, and he related all the local gossip and events, trying to create her presence by talking of common friends and places. The doctor had gone to Cromer using his own carriage and horses, the loss of one of them emphasising his extravagance at paying £130 for the pair. Cromer, "the best of all sea bathing places," with a fine open sea and pure air as recommended by Mr Perry in Jane Austin's *Emma,* was one of the growing resorts which were mushrooming as a result of the belief in ozone as a cure all. There is a note of one-upmanship in the doctor's offer to Abram Constable of lobsters "if he should come that way". The Constables did not follow such fashions.

It was a good summer; fine weather and a good harvest made painting in the open air doubly enjoyable. John Dunthorne's son, another John, was given occupation grinding colours and so made his first appearance in Constable's painting life. Local elections caused a bustle around the countryside and the village itself had an event to talk about which Constable passed on to Maria; "The bear is dead and Mr Eyre is inconsolable, he loved it dearly though he has the marks of its teeth in many parts of his body". Mr Eyre was one of those in the parish not on good terms with the rector, who himself had problems on his return from the sea side. A lady claiming his acquaintance in the past visited the village and paid him too much attention despite his insistence that they had not met before. His discomfort greatly amused Constable who commented, "Is it not very shocking that at the age of four score we cannot descend quietly into our graves for the kindness of a number of old women."

A portrait of the Bishop of Salisbury took him to London. Here his lodgings had suffered from a fire in his landlord's shop downstairs. Fire was a very common occurrence in the city and he was lucky not to lose any of his possessions, but the rooms were in need of some repair so a portrait of Captain Western of Tattingstone (near Ipswich), "a very large subject," was convenient as he went back to Suffolk and stayed over Christmas.

On returning to London in January 1813 he learnt that Maria had been unwell and was so solicitous in his enquiries after her that even the mild Mr Bicknell was tried to such an extent that he forbad Constable the house in Spring Garden Terrace. Although this was a great insult and very hurtful to *his* feelings the slight was felt just as painfully and probably with much indignation at East Bergholt House.

As ever, the lovers were able to arrange secret meetings when Maria's health improved and Constable managed to refrain from writing until May when he could report in a carefully worded letter that his superiors in the Academy approved his pictures in the new exhibition and considered that he was making advances in his work. And just to prove that he was not in the rank and file of artists he gave an account of the banquet given to celebrate the opening of a special exhibition honouring Sir Joshua Reynolds arranged by the British Institution, which was attended by those most important in the art world and the Prince Regent. Even more important was the news he could send next month before leaving for Suffolk, "I am now leaving London for the only time in my life with pockets full of money. I am entirely free from debt (not that my debts ever exceed my usual annual bills) and I have required no assistance from my father for some time". Portraits — he could now ask fifteen guineas for a head — were stabilising his income but even with this evidence of his continuing rise in position Mr Bicknell still refused to allow any sort of communication between him and his daughter.

To ease his feelings Constable once more threw himself into painting so intensely that he hardly noticed the best harvest in years during the glorious summer. With winter his usual lowering of spirits came on, this time accompanied by a really desperate tension. Hanging about cold streets hoping for an accidental meeting, or even a sight of Maria, worsened his mood. 1814 started as the coldest for years, so cold was it that the Thames froze over and London enjoyed a Frost Fair on the ice. Constable was in no mood for gaieties. The streak of melancholy in his nature took him over as he saw yet another hopeless year beginning, he turned hermit and even stopped writing to East Bergholt. Constable was always a domesticated being and his depression was partly that he was missing the status and completeness of the married man, instead of being the bachelor always on the outside, like someone looking through the window of a cosy lighted room on a winter's night. He needed Maria also because he had discovered what every true artist discovers, the loneness of artistic creation. To some this does not matter so much but to Constable just as he needed contact between nature and man in his pictures it was necessary for him to be painting *for* someone and not just in the hope of some future appreciation which in all probability he would not live to see.

On 19th February he poured out his feelings to Maria in a letter which would move a stone, let alone someone equally despondent, "You must I am sure my dearest Maria be aware how much real pain you gave me when you mentioned (with an air of gaiety) that you was lately so near me — can I avoid recollecting by that circumstance, that there was a time when your father would not have passed my door but was calling on me with you on his hand, and inviting me to his house when he knew of our mutual attachment. Is it possible for me to help contrasting that happy time with the present, when I am alienated from my

John Fisher (1788-1821) became the close friend of Constable in 1811 when the artist was visiting the Bishop of Salisbury, Fisher's uncle. This was the start of an intimacy which lasted the rest of his life.

Fitzwilliam Museum, Cambridge *Oil on canvas* *36 x 30.5 cm.*

family and society, and all intercourse with the object of my affections, the only woman I ever loved in the world, as much as possible prevented, and that which is our highest virtue endeavoured to be rendered a crime. You must think with me that my punishment fully equals my offence.

The steadiness of your affection for me my dearest Maria has been my support in numberless hours of the deepest distress — for all my hopes and prospects in life are included in my attachment to you — but I am warned by my sufferings — years drag on — and no friendly hand is offered for my succour — the fates are still unrelenting.

Could you make a noble effort in my behalf, you could never regret it — you would make the latter years of my parents happy, and save me to the Art for which I have made many sacrifices. Here is a home which you once said satisfied you — it would at least do for the present — and we could never want — for independent of what I have of my own (which shall be yours) I have many valuable friends who would patronize me, especially Mr Watts — but they see it is of no use situated as I am."

Salisbury Cathedral. Constable made a number of visits to his friends of the Fisher family over the years and the Cathedral, despite his distaste for the restrictions of drawing architecture, appears in many paintings and drawings.

Family collection *Pencil* *9 x 11.5 cm.*

St James' Park by Rowlandson. Constable wasted many hours walking in this favourite London airing place in the hope of meeting Maria "accidentally".

Museum of London *Drawing* *16 cm x 24.5 cm.*

Maria could have been no less serious in intent than he but still she delayed taking the decision and setting a date for the wedding. Probably her dithering father played upon her nerves concerning the fate of her sisters if they had no dowry, and there was always the ill health of her mother to consider. The strain between her and Constable was telling and the lack of "that most necessary evil money" was a source of contention between them. To this was added the strain he was feeling each day that he was wasting his time hacking away at portraits when he wanted to be working on landscape for he now knew he had the power and resources to create an art form of consequence.

London was once more enjoying the Prince Regent's flair for entertaining, the visit of the Tsar of Russia and celebrations to commemorate Napoleon's abdication gave everyone something to talk about, but Constable went off to East Bergholt still in low spirits and while staying at Feering in Essex visited the ruins of Hadleigh Castle and made several drawings of the scene. From these drawings would come the great oil painting he made after Maria's death. Here at one of the lowest points of his life the melancholy ruins against the wild element of the sea struck the right note in his imagination.

In East Bergholt he was much affected by the beauty of the countryside where they had once been happy together and buried himself in painting to the exclusion of all social contact with friends and neighbours: he was much annoyed

at having to waste time painting a new uniform on to the previous year's portrait of Captain Western who had been promoted to Rear Admiral. Such are the trials of the portrait painter.

From the turmoil of his emotions was being formed the fully mature painter of landscape. As Proust said, "The mind of the creative man is like an artesian well. The deeper the level to which his sufferings can sink, the higher the level to which its productions will rise." Two paintings from this summer and autumn could be called Constable's first masterpieces. As a wedding present for Philadelphia Godfrey, the squire's daughter, he was commissioned to paint her a reminder of her old home to take with her to London. *Stour Valley and Dedham Village* now in the Museum of Fine Arts, Boston is the view he made of the valley with men carting muck from the giant heap in the foreground. It shows how far he had progressed towards making a fully rounded statement about his own artistic beliefs. The Godfrey family was one of those who had encouraged him from the start of his painting interests so it was doubly important that this picture should be a fine one. Muck carting may seem an odd subject for a wedding present but it shows the matter of fact attitude to all country work which he felt was worthy of being used in painting.

Another familiar scene gave him his second great picture, *Boat Building Near Flatford Mill,* now in the Victoria and Albert Museum, was painted during

Flatford Mill gave Constable many pictures during his summers spent painting in Suffolk. This unusual view is taken from Willy Lott's cottage looking back at the mill.

From the collection of Mr and Mrs Paul Mellon *Oil on panel* *16.5 x 30 cm.*

the autumn. It has the limpid golden light of Claude and the classical artists, but no one of them would have painted such a mundane scene as this with its country craftsmen building a working barge amid a litter of tools on a hot summer day in Suffolk. Lucas said that Constable knew when it was time to finish painting each day by the smoke from the cottage chimney which indicated that the occupant's supper was being prepared, so this picture must have been painted out of doors which makes it a remarkable meld of realism and classicism.

Both these paintings show the extent to which he had assimilated the works of his favourite masters, and from his love of Claude and the Dutch school he was creating a new art in which the painter was as much a part of the landscape as the sky, trees and earth itself. He was not to complete the simbiosis for some years but 1814 saw the first major stage achieved. The serenity of *Boat Building Near Flatford Mill* does not betray his disturbed feelings while he was painting it and poor Maria's life was not untroubled either. Caught between her negative family and her positive lover she constantly attempted to placate one without losing the affection of the other and the persistent ill health which dogged the family, as well as her own delicate constitution, was an added complication.

This summer she had gone to Brighton with her ailing mother and worried Constable by going bathing in October. Despite her father's position in London the Bicknell family life does not sound very enticing. Much of each year was spent moving from one visit or rented house to another in search of better air and health. Maria's portrait painted by Constable in 1816 suggests a gentle character but one with much quiet determination beneath the mild exterior. Certainly she was good looking enough and from a suitably desirable background to have attracted suitors and her father must have sighed for someone of whom Dr Rhudde would approve during these difficult years, but she remained unmarried and there is no indication that she gave Constable any cause for jealousy in the years before they married. Sometimes the difference in their ages shows and perhaps up to this year she did not really understand the strength of passion in either the man or the painter and had enjoyed having a devoted suitor without committing herself to the trouble and discomfort of an opposed marriage. But this dreadful year of 1814 brought home to her that she was dealing with a far from ordinary man whose depths could go very low and only she could rescue him from a further plunge.

Her own patience and determination brought some result at last: in February 1815 Charles Bicknell suddenly relented and Constable was once more allowed to call at Spring Garden Terrace as an occasional visitor. His happiness was short lived. On 9th March, Dr Rhudde's eighty-first birthday, Mrs Ann Constable had an attack which partly paralysed her and she shortly died. The centre was gone out of the Constable family and with her death John Constable lost not only his mother but one of his closest friends and most partial supporters.

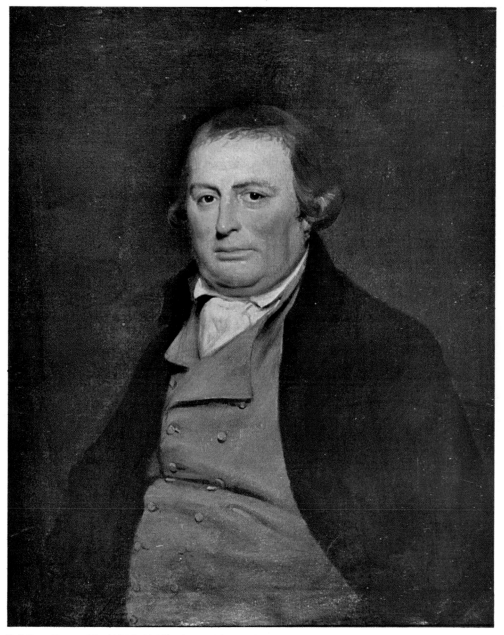

Golding Constable (1739-1816) shows him to have been the shrewd yet honest merchant his business success and reputation indicate. This may be the portrait Constable began of his father in 1815, which he thought promised to be his best.

Family collection *Oil on canvas* *76 x 62.5 cm.*

In 1815 Constable painted the background on George Dawe's portrait of the currently popular actress Eliza O'Neill in her role as Juliet. He found such collaboration hard labour and this is his only known example.

Provenance unknown *Oil on canvas*

Hollyhocks shows that Constable was no mean painter when he turned to the smaller details of the countryside. He later gave instruction to his daughter Isabel who became a flower painter.

From the collection of Mr and Mrs Paul Mellon *Oil on board 23 x 16.7 cm.*

The loss was deeply felt and before he had time to recover from it Mrs Bicknell also died, on 12th May, and he wrote to Maria, "That we should both of us have lost our nearest friends (the nearest we can ever have upon Earth) within so short a time of each other is truly melancholy — and more than ever do I feel the loss of your society. Indeed I never felt the misfortune of our being apart more severely than at this moment, as I am convinced that we should be a mutual comfort to each other — I assure you I sincerely feel the want of that comfort which your excellent and religious mind could only afford me." At this time he was at East Bergholt but it was a melancholy visit, his father was still in fair health although becoming weaker and much shocked by his wife's death, and Abram was in all effect the head of the house and the business. Neither of his sisters could replace their mother, the aura which had enveloped them all since childhood was broken and instead of being one unit they now found each one was separate. More than ever Constable felt the need for marriage and the chance to create a home with Maria, who now had full responsibility for the Bicknell household in addition to comforting her father.

Tragedy comes and goes but work is immortal; Constable's capacity to throw himself into it looking neither left nor right took him through the next few difficult months. During June he was engaged upon his only known collaboration which was with George Dawe on a portrait of Miss Eliza O'Neill as Juliet. Miss O'Neill was one of the fashionable actresses who regularly became the craze of London. The previous year she had been acclaimed a great success in the role so it was in this guise that Dawe was painting her portrait, Constable undertaking to paint the passion flowers and background to the figure. Collaborations were quite normal amongst artists inclined to commerce but it was an unusual enterprise for Constable which he undertook for reasons best known to himself. Perhaps he wanted the chance to work on a larger canvas than any he had attempted before, perhaps to see how a professional face painter worked on such a piece. At any rate it was an experience he did not repeat again as he soon felt he had sold himself to the other painter and that his time was not his own until the work was finished. To this end he spent long hard hours on the picture and Dawe was pleased with the result, suggesting a continuing business arrangement but "painting does not readily admit of partnership," and as Constable told Maria, "I have done at Mr Dawe's and I have given HIM great satisfaction — but I have persisted in making him no future promises, though I do not say I will never work for him again. He is an overmatch for me, because he is not a gentleman — you see how I can speak treason to you."

All London was waiting to hear the result of the French campaign since Napoleon had escaped from Elba and the battle of Waterloo was fought while Constable was battling with Miss O'Neill's background. News of the injured and

The special qualities produced by light and water were a constant challenge to Constable and he frequently tried to capture in paint the sparkle and glistening effects with which he had been familiar since childhood.

Family collection

Oil on canvas

15.5 x 25.5 cm.

dead was slow being released so that the family had a long wait before learning that James Gubbins, Constable's favourite cousin and "one of the most interesting men I ever knew" had been killed.

This sad event hung over the summer which brought its usual separation, Maria spending it in a cottage on Putney Heath and Constable returning to East Bergholt. Once more he concentrated on work and avoided the social round, although he could hardly have avoided the peace celebrations when a public dinner was held in the open in front of the house. Tables were set up and although there was too much bread and not enough beef and the beer ran short and the band did not arrive until after dinner the event was much enjoyed, finishing with fireworks in the evening. This year he felt freer and more confident that before long Maria would be his wife and he could declare, "My affection and determination towards you are fixed for ever, and gain in strength by time. We have certainly got the worst over — and as we have borne so much and so long, would it not be wiser yet to listen a little longer to the voice of prudence?" He was wrong, the worst was not yet over for them but it is amusing to see that it is now he who advises patience and Maria who complains of the separation. "How I do dislike pictures, I cannot bear the sight of them, but I am very cross am I not? I think you will not bear this letter, you may spare yourself telling me I am unreasonable for I know it already, but I cannot be reconciled to your spending month after month in the country." This time he was staying on not only for the sake of his painting but because old Golding was in a weak state and at one point appeared to be dying. However he rallied enough to take an interest in the next great event at East Bergholt; during January 1816 under a Bill of Enclosure the common was being enclosed and divided into fields. The quickly painted panel known as *Spring* in the Victoria and Albert Museum may be a "snapshot" record of the historic ploughing of the old common made to show Golding who could not leave his room.

Evidently there was now renewed opposition to the match from Dr Rhudde and his younger daughter Mrs Farnham for Maria's spirits were low and it was Constable who now had to be the calm and stable partner when he urged her "do let me entreat you to be calm, and let nothing that may be said vex you . . . Believe me my dear girl that I love you entirely and nothing save the death of either of us shall prevent our being happy together. We can never be rich, but as a balance to that we have what riches cannot purchase and what our greatest enemies can enhance by persecution but cannot deprive us of." He now did something which pleased her very much, he formally ended his friendship with John Dunthorne although it had been fading out for some time. Perhaps Dunthorne's reputation for atheism and hostility to Dr Rhudde had been an embarrassment to Maria but "as he was determined to continue in his perverse and evil ways, I was determined not to countenance them by being seen with him". The break greatly

relieved Maria, "You have made me very happy by the conduct you have pursued in regard to Dunthorne, he never could be a fit companion for you. I am delighted the acquaintance is broken off, I trust for ever, a man destitute of religious principle must be, if not a dangerous, at least a most melancholy associate. It has certainly been the astonishment of many that a man so every way your inferior, should be allowed and honored with your time and company, I assure you it has been a subject of wonder to me."

What may have been in part an attempt at conciliating Dr Rhudde failed utterly as inadvertently Constable spoke to Miss Taylor, who ran a school for young ladies in East Bergholt, concerning Catherine, Maria's youngest sister. Miss Taylor went to discuss the possibility of his grand-daughter attending her school with Dr Rhudde, who knew nothing of the matter. It was thus revealed to him that not only was Constable still communicating with Maria but taking more than a casual interest in the affairs of her family which he considered to be *his* affairs. Mr Bicknell received a characteristic chastisement by letter which shook his equilibrium greatly and worried Maria, although Constable treated the matter as of no real consequence. The declining health of his father presented by far the more important worry on his mind and on the subject of the rector steel entered his soul. The cantankerous old man's pronouncement on Maria that he no longer considered her his grand-daughter only strengthened his resolve that they should marry, the sooner the better, and that they had been fools not to have married long ago. The near presence of death made the backwards and forwards game they had been forced to play for years seem more foolish than ever. He saw that if they went on waiting it would be for year after year, and they would have little life together, so he did not agree with Mr Bicknell's advice that if they waited the rector would change his will back again and Maria could then receive her share of the inheritance. "It is not my intention to wait longer than the summer — then in spite of A, B or C let us for God's sake settle the business — then let those divide us who can".

This was not the most romantic way of settling a wedding date but his determination supported Maria and the venture became more possible in May when Golding Constable died. From his share of the estate Constable could now look forward to an income of some £400 a year. The milling business had been left to Abram to manage for all the family who would each draw an annual income from it and this, with capital from the sale of East Bergholt House and the income from his painting, Constable thought security enough for marriage. He therefore made Maria agree to a September wedding, come what may.

A further death was added to the list of the last two years, that of David Pike Watts in July and with this Constable lost a generous benefactor but did not, as might have been expected by the favourite nephew of an uncle without a male heir, benefit from his will as all the fortune passed to Pike Watts' daughter.

Boat Building Near Flatford Mill painted in the open air during the summer of 1814. This is a fully mature synthesis between the great landscapes of Claude which Constable admired and his own determined conviction of the artistic value in his Suffolk countryside.

Victoria and Albert Museum *Oil on canvas* *51 x 61.5 cm.*

Constable was ever employed at his art. This drawing of Netley Abbey is one of many works which resulted from the honeymoon trip to the south coast which he was able to make with Maria after their marriage on 2nd October 1816.

Family collection *Pencil* *9 x 10.5 cm.*

Leslie relates that Constable was so partial to the Suffolk breed of cattle that he painted them in wherever the location of his subject. They seem to have been mostly notable for their lean appearance.

Family collection *Pencil and chalk* *18 x 11 cm.*

Constable himself was not disappointed, having expected nothing, but curiously enough Dr Rhudde was vocal in expressing his disapproval of the way he had been treated by his uncle. And equally curiously followed this by declaiming against him in the village as an infidel.

This month Constable visited Maria taking for her a spaniel, Dash, from East Bergholt and it was probably on this occasion that the scene took place which Leslie records for when Constable "placed himself beside Miss Bicknell, and took her hand, which was soon to be given to him for life her father said 'Sir, if you were the most approved of lovers, you could not take a greater liberty with my daughter' " — "And don't you know, Sir" he replied, "that I am the most approved of lovers?" Maria's part in the conversation is not recorded but she must have seen that a break was unavoidable now.

Mr Bicknell was still being obstructive in September when Constable sent Maria a letter he had received from his friend John Fisher, who had himself been married to a cousin of the poet Wordsworth on 1st July, offering to perform their marriage ceremony when he was in London at the end of the month. Maria could report that her father "merely says that without the Doctor's consent, he shall neither retard, or facilitate it, complains of poverty and so on. . ." To be married by a close friend, who was also nephew of the Bishop of Salisbury and himself Prebendary of Sarum, would surely mollify Dr Rhudde and prove that his grand-daughter was not marrying an infidel. Constable wrote a polite letter to inform his old enemy of the intended marriage but received no reply.

"Take from me my palette and paints and I am the most helpless creature on earth," by summing himself up in this way Constable was very accurate. Having pushed events to a near conclusion he nearly spoilt the final few weeks of the drama in which they had been involved for seven long years. Weddings were not the showy social occasion they later became but he was more than insensitive to Maria's query as to dress for the ceremony, "You talk about clothes. I wish not to interfere — I always wear black myself and think you look well in it, but I should say the less we cumber ourselves in that way the better." Maria replied that she disliked black very much and furthermore felt that he was worrying too much over being unable to accept some portrait work which had come his way. It was one of those last minute crises which tear the nerves and become magnified easily into a tense situation. For he was now suddenly panicked over their lack of money and replied sharply, "I like black best — do as you like — but I should think it advisable not to spend your money on clothes, for we have it not to waste in plumb cake, or any nonsense whatever."

It was by now 22nd September and still Constable delayed in Suffolk, excusing himself because one of the subjects of a commissioned portrait was aged and declining so fast that he felt he had to secure the likeness lest it be too late when he could next get to the country.

Poor Maria! Living with her irritating father and her sister who would hardly speak to her, the bridegroom for whom she had suffered so much and was the reason she was now being disowned by her family seemingly having more important matters to attend than the marriage for which he had pressed over so many years. He was always notorious for delaying his return to London once he started painting in Suffolk so she just had to wait, surrounded by her hostile relations, wondering if she would eventually be married or not. Even when Constable did finally arrive back in London things did not go smoothly and the arrangements were at sixes and sevens until finally on 2nd October they were married by John Fisher at St Martins-in-the-Fields with apparently no member of either family present; Maria had parted from her relations after a heated exchange and Constable had left his invitation to his sister Martha too late for her to attend. Whether Maria wore black is not recorded but in that empty church came a strangely quiet end to one of the most extraordinary and long courtships.

The bride was now twenty-eight, her groom forty-one and they spent their honeymoon in the south of England visiting the romantic ruins of Netley Abbey before taking up John Fisher's invitation to stay at the vicarage at Osmington with him and his wife of four months. The two couples stayed here until November, the wide sweep of Weymouth Bay giving Constable plenty of painting material for he was ever practical when it came to his work and unlike other artists who travelled Europe for fine views found his subject matter wherever he happened to be. After staying a few days in the Bishop's Palace at Salisbury the new Mr and Mrs Constable returned to Charlotte Street ready to begin their married life and face whatever difficulties it would bring them.

A drawing of the steam packet *Orwell* which began a daily service from Ipswich to Harwich in August 1815. The voyage took only 2½ hours but the innovation was not a great success and was discontinued in October. Constable was evidently intrigued by this nautical oddity for he made an etching from this drawing and the vessel also appears in another drawing he made at Harwich.

Family collection *Pencil* *7 x 10 cm.*

CHAPTER FOUR

"It has a more novel look than I expected"
John Constable

CONSTABLE had spent the sixteen years before he married as a period of collecting and waiting, both in his personal life and his painting. The fullness of the coming years had been heralded by the painting of *Boat Building* but the period of his life before marriage is more notable for the variety it encompassed, though far from involving less work than the rest of his life, and it lacked a centre. Those long years as a bachelor had denied him the happiness of wife and family and the security of the place in society enjoyed by the married man and which he much desired. But they did give him the freedom to spend longer hours painting or out in the countryside, or looking at pictures than he could have managed as a married man.

With marriage coming after his career had gone through its formative phase he could start on it without the added disadvantage of beginning in his profession at the same time. True he was not a great financial success but he was becoming established in his chosen field and had every hope and confidence now for the future. Those summers spent at East Bergholt during the last sixteen years had given him the artistic vocabulary and means. And from them, in his oil sketches, watercolours and drawings he had more than enough work to last a lifetime. The intensity of his feelings can be sensed from the small sketch books he always carried in his pocket. Their pages, often only three or four inches in size, are closely crammed with everything he saw, farm implements, church towers, plants, people and animals, the tiny pages even being subdivided sometimes to get several drawings on one sheet. From the young man who had gone to London to study painting and who knew his native region as a countryman, because he had lived in it all his life, he had become an artist and knew his countryside as an artist and had within his grasp the means to transform it into art. With the happiness which his marriage released in renewed energy and confidence the future looked as if it were his to command.

In his painting room he worked at his best picture to date, *Flatford Mill on the River Stour,* which sums up all his feeling for his early life, the idyllic summer days in which childhood seems to have always been spent: work and pleasure existing naturally side by side in an unstrained partnership. It also shows his mature handling of paint and the serene strength his marriage had brought. One of his favourite ways of referring to Maria, "my placid companion", expresses the feeling emanating from this picture, peaceful assurance and hope.

Once Constable and Maria were settled in Charlotte Street the soft hearted Mr Bicknell was soon won round and forgave his daughter. Even Dr Rhudde seemed more inclined to view the couple with, if not favour, at least not outright hostility. Soon he changed his attitude for his temperament, as shifty as a weather-vane, continued to swing round and round until his death. However in London, more worrying for Constable was the fact that Maria suffered a miscarriage in February and her next pregnancy which started immediately made him think seriously about her health. The bachelor lodgings, he now realised, were unsuitable for a delicate wife and a young family so he set about looking for a house and soon found 1 Keppel Street which was conveniently near the centre of London, but still very rural. Keppel Street has since been demolished for the London University School of Tropical Medicine and Hygiene, but then it looked over fields and large ponds and there was even a pig farm close to the British Museum in Great Russell Street.

While Maria rested and breathed fresh air at her father's cottage on Putney

The confidence finally released through his long awaited marriage resulted in the full flowering of Constable's genius. This large painting *The White Horse* was the first of his great exhibition pieces.

Oil on canvas *130.5 x 185.5 cm.*

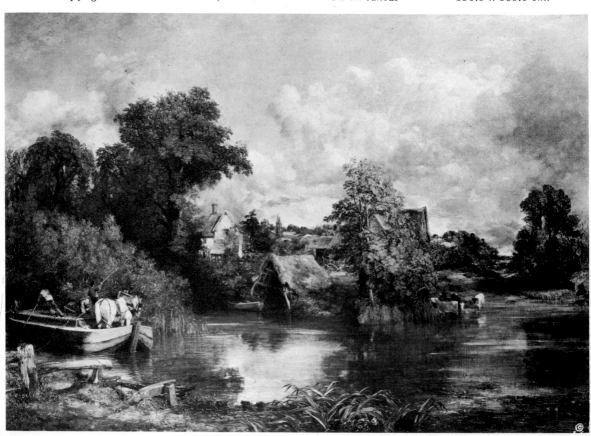

Heath her husband undertook the arrangements for painting and decorating the new house and then furnishing it before taking her for a long stay at East Bergholt: here he had the satisfaction of taking her to visit friends like the Rebows who had wished them well during their difficult years of courtship and could now welcome them as man and wife. Painting of course continued as hard as ever for Constable now had every spur to win acceptance for his work.

Any artist who hoped to achieve honour had to enter the Royal Academy first as an Associate and then as a full Academician. Associates were voted in by the Academicians and then had to wait until one of the full members died before he could take the vacant place and put the letters R.A. after his name. The jockeying and political skullduggery which went on behind the scenes to win votes was not to Constable's taste at all. If, as he fully expected, he entered the Academy it would be on the merit of his pictures and not on the numbers of votes he could acquire by pandering to those in power. It is therefore not surprising that he had met with no success whatever so far. But at the elections of 1817 when he once more failed to win the letters A.R.A. he did receive more support than ever before so he felt more than heartened and confident that one day Maria could be proud of her husband.

The first full year of their life together thus ended on a high and optimistic note, established in their own home, his professional status growing and on 4th December the birth of a son, John Charles, completed their happiness. Portraits were still the basic source of income but East Bergholt House was up for sale and if sold well would bring some stability to their finances. Abram and Mary were making improvements to the house at Flatford Mill and Ann was preparing to move with her animals into a house on the heath. Golding was already settled in a house on the Dysart estate at Helmingham.

The sale finally went through the following November and while the home which had been the centre of his childhood was being sold Constable was working on his first six foot canvas *The White Horse;* this is also the first of an unintentional series of large paintings all associated with the Stour. Not only was it his largest and most ambitious work to date, it even won some critical approval when exhibited, and that was something he had never enjoyed in abundance.

The picture shows a grey barge horse being poled across the river from one bank to that opposite at a point where the tow path changes sides. The light is completely different from the warm golden glow of *Boat Building* and the anecdote in the form of the barge, horse and men poling predates a public taste which is far ahead of its time. It is the forerunner, the rehearsal or trial run he made in using such a size of canvas and, although a fine picture, does not live up to those which were to follow. The overall conception is grand and the eye is led into different channels of perspective successfully but the picture has trapped the artist into painting too many particulars, into putting down truths, but his inter-

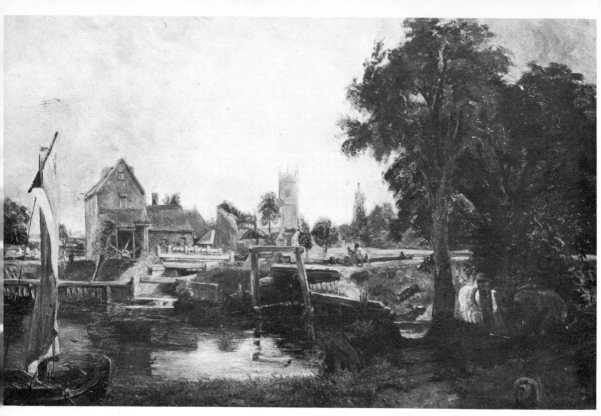

Dedham Mill and Lock is one of several sketches Constable made of the scene. His father had acquired this mill during the early days of his business and it remained in the family until 1846. The site continues in the milling trade but on it stands a modern building.

From the collelction of Mr and Mrs Paul Mellon Oil on paper mounted on panel 30.5 x 47 cm.

pretation of those truths was too literal. In small sketches he had long since reached the point of being able to extract a spiritual truth from what he saw. This large canvas was the testing of his abilities to weave many truths and sensations into a major work of genius. It revealed him as not quite trusting his instinct, still measuring himself beside the great masters of the past, not keeping his intelligence in sufficient balance but letting it over-ride his creative desire, and by trying too hard, just failing in his purpose.

The White Horse was shown at the Academy in May 1819 and on the third of this month Abram wrote to say that Dr Rhudde, who had been in a failing state for some time, was not expected to live much longer. Constable took coach to Suffolk and arrived on the sixth only to find that the rector had died that morning. His last will revealed that he had after all left Maria an equal share in his grandchildren's inheritance — £4000 of stock which could bring the Constables' income up to a very comfortable level. At East Bergholt the death soon drifted into the village past and Abram could write, "We never hear the Doctor's name mention'd in any way whatever, *clean gone.*" So it was that the cantankerous old

man whose whims had bedevilled so many years of Constable's life now opened the way for him to apply his whole concentration on his true *metier,* landscape painting. A further joy, for he was exceedingly fond of children, was the birth in July of a daughter, Maria Louisa, which was enhanced by hearing on the morning after the birth that John Fisher would buy *The White Horse* for one hundred guineas, twice as much as he had ever received for a landscape before.

Just as their prospects were really looking up Maria's always delicate health now took a downward trend from which she would never really recover. They rented a cottage at Hampstead for a while and started the pattern of many such removals to the heights of the Heath or to Brighton, in search of better health for her and the children. So the strain of running two houses which was to become such a burden in the future began as soon as their financial position improved. It was in the years now beginning that Constable most felt the value of his friendship with John Fisher.

The two men had many characteristics in common, both had country childhood experiences behind them and they shared a strong love of nature, both combined piety with patriotism, conservatism and an uncomplicated down-to-earth sense of humour, and, in Fisher, the optimistic temperament to support and encourage his friend through the periods of black despair he sometimes suffered. The sound advice he had given during Constable's courtship had been a steadying influence, and he was largely responsible for making him take the final step and marry when he did, and the faith he had in his friend's talents from the very start of their friendship and his patronage at a time when no one else would buy, were beyond calculation.

Fisher himself painted and was sensitive to the same effects of nature as Constable and when he describes a ride in September 1820 it could well be the

Constable was renowned for his love of children, this drawing is probably of his first daughter Maria Louisa born on 19th July 1819.

Victoria and Albert Museum *Pencil* *6 x 10.3 cm.*

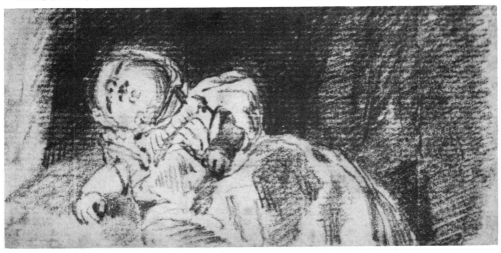

View in a Garden with a Red House beyond is one of many small oil sketches Constable made at Hampstead when he took his family there to find fresh air.

Victoria and Albert Museum *Oil on canvas* *35.5 x 30.5 cm.*

artist, their observations are so in tune; "This season of the year with its volumes of rolling clouds throw the finest effects over this beautiful country. A large black misty cloud hung today over the sea and Portland. The Island could be but just discerned. The smoke of Weymouth was blown towards Portland and was illuminated by the Western sun and relieved by the dark cloud. As I rode home a complete rainbow came down to my very feet: I saw my dog running through it."

His purchase of *The White Horse* gave Constable's ambitions a boost at just the right time. When it was hung in the Fisher home, Leydenhall, in the Close at Salisbury he wrote, "It is hung on a level with the eye, the lower frame resting on the ogee: in a western side light, right for the light of the picture, opposite the fireplace. It looks magnificently. My wife says that she carries her eye from the picture to the garden and back again and observes the same look in both." A comment which gladdened the heart of the painter and is one of several which were applied to his works which pleased him, all were spontaneous appreciations and did not come from the artistic pundits with whom he was getting more and more impatient. Their carping and back biting had nothing in common with his own spontaneous feeling when confronted by nature. This had been reflected in his comment to Maria during the spring when he had repeated a remark made to him on a walk with Wordsworth a few years previously by saying, "Everything seems full of blossom of some kind, and at every step I take, and on whatever subject I turn my eyes, that sublime expression of the Scriptures, 'I am the resurrection and the life', seems as if uttered near me."

While he was working on the next large exhibition piece in November 1819 he was at long last made an Associate of the Royal Academy, defeating by eight votes to five C. R. Leslie who was to become the close friend of his later years and his first biographer. It seemed that everything was turning in his favour at last, although he must have felt rueful if he counted the twenty years it had taken him to become an A.R.A., which honour usually followed shortly after an artist had left the Academy Schools. His new picture which he called *Landscape* as he was never over concerned with titles, has since become known as *The Young Waltonians* or *Stratford Mill* because of the group of boys fishing at Stratford Mill in the foreground. Completely different from its predecessor in its forceful tone and fresh light effects it is the first major work in which he has worked particulars (for every item in his paintings stems from seen particles) into an artistic unity which stands as an individual expression and a forceful statement all his own. Constable himself was pleased and for some years considered this his best painting. When it was exhibited even the critics approved, one of the newspapers said, "*The Landscape* by Mr Constable has a more exact look of nature than any picture we have seen by an Englishman, and has been equalled by very few of the boasted foreigners of former days, except in finishing." Constable was constantly attacked for the lack of 'finish' on his pictures in England which could not appreciate the

vigour of his surfaces and the innovations he was making by using a rapid brush-stroke as a symbol for the form it was representing and thus emphasising his theme of pictorial unity.

The critics might like the picture, but no one bought it, and it was again John Fisher who stepped in and later purchased it as a gift for his lawyer John Tinney as a reward for conducting a successful lawsuit. The two friends were able to spend that summer together for the Constables took their children by coach to stay at Leydenhall. During the two months of the visit they painted and walked around Salisbury. Visits to Stonehenge, Old Sarum and the New Forest gave them both plenty of subject matter and it was one of those high points in a friendship, when both participants are concentrated on the same interest, which come to symbolise the whole. Their wives and children were happily settled together and the problems of financial support and simply enough space for expanding families had not yet shadowed their lives.

On their return to London Constable took Maria and the children straight to Hampstead for the city was in a disturbed state. The Regency had ended in January with the death of George III and now the wife of the new King had returned after years of public frolicking on the continent to claim her crown. The eccentric behaviour of Caroline of Brunswick had gnawed at the Regent's reputation for years and he now viewed with horror the thought of sharing his throne with her. Accordingly he sent to the Cabinet the green bag in which he had stored all the unsavoury evidence collected during her years abroad in the hope of

Although he disliked painting portraits of architecture Constable's finances were ever in need of improvement so he accepted the offer from his patron Henry Greswolde Lewis of a commission to paint *Malvern Hall*. This is one of the studies made there in 1820.

Family collection *Pencil* *11.5 x 18.5 cm.*

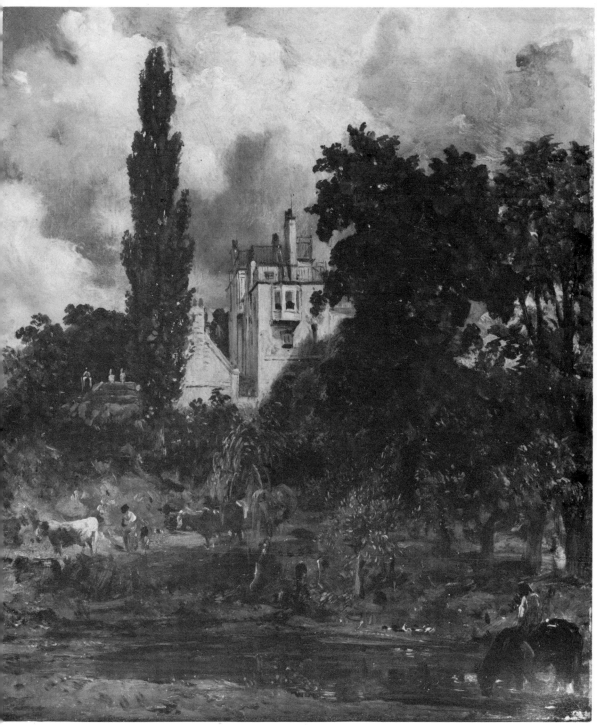

The Grove, or Admiral's House, Hampstead c1820, one of Constable's finest oil paintings.
The Tate Gallery, London *Oil on canvas* *35.5 x 30 cm.*

arranging a divorce. The wave of popularity which greeted her was a direct contrast to her husband's lack of public support, and to make things worse the Duke of Kent (the new King's brother) had also died in the same month as his father so that in the next generation the heir to the throne was his young daughter, Alexandrina Victoria, who was only nine months old. With the succession dubious and the coronation postponed the country was unsettled and became even more disturbed by the Cato Street Conspiracy. A group of radicals who met in a hayloft in Cato Street planned a violent blow against authority in the hope of raising the country against the repressive government, but they were betrayed by an *agent provocateur* infiltrated into their group. Their execution by hanging and beheading made a fine public spectacle for Londoners but there were many who thought that this was going too far, the age of serious social conscience was dawning.

Constable was one who did not share in the enthusiasm for Queen Caroline and after he had settled his family at Hampstead he wrote, "I am glad to get them out of London for every reason — things do not look well though I fear nothing — but the Royal Strumpet has a large party — in short she is the rallying point (and a very fit one) for all evil minded persons." The King could not get a simple divorce so a little known Bill of Pains and Penalties was extracted from the archives with the aim of proving Caroline guilty of "conduct of licentious character". Her trial in the House of Lords occupied London that autumn. Special galleries were built, there was little else heard in gossip and as a public spectacle it developed into farce underlaid with political intrigue and ended with anticlimax in November when the Bill was dismissed.

It all annoyed Constable intensely for he had more important things on his mind. Samuel Bicknell, Maria's twenty-two year old brother was dying of consumption, Maria herself was pregnant and bore another son, Charles Golding, on 29th March and during this winter he was working on another large canvas for the exhibition. The subject was one he had often used, the mill pond at Flatford with the house of W. Lott. Its owner was so attached to his home he was said to have spent only one night out of it during his long life. It was then known as Gibeon's Farm, only later it achieved notoriety as "Willy Lott's Cottage".

John Fisher refers in one of his letters to a coming visit he will make to London "when I hope to see the Hay wain in a good light" — with this casual reference he names what has become one of the most famous paintings in the world with its best-known name. When the picture was exhibited at the Academy in May 1821 *Landscape — Noon* did not distinguish it very readily from any other landscape painting by any other artist. Constable himself felt, "The present picture is not so grand as Tinney's owing perhaps to the masses not being so impressive — the power of the Chiaro Scuro is lessened — but it has a more novel look than I expected." Not the most enlightening statement about the picture which was to

affect the course of European painting and make his name a commonplace in every country since.

 The Hay Wain has suffered much from over popularity since it was painted, known through thousands upon thousands of reproductions it appears on tea trays, table mats, biscuit tins and tea towels and is found on as many walls in print form as the famous flying ducks. So popular has it been that the painting itself, now in the National Gallery, comes as a revelation. Through poor reproduction it often appears brown and fusty, just what Constable was fighting in landscape painting but in reality the subtleness of greens and play of light through trees and grass have a freshness which is still telling. What he said of the lessened chiaroscuro is true, it is less dramatic than *Stratford Mill* but it gains in monumental stature. The air is neither limpid or stirred by romantic emotion, it is clear with all the warmth of a fine June day. The picture is a window on to a Suffolk valley which is made into a symbol for everything true in nature and, as he was a very devout man who saw nature as creation, true in god.

Sketches like this for *The Hay Wain* today stand on their own as valid statements and are appreciated by modern taste more than the finished works which evolved from them. To his contemporaries, like Sir Thomas Lawrence, Constable's work was "ferocious Art".

From the collection of Mr and Mrs Paul Mellon *Oil on paper on canvas* *12.1 x 18 cm.*

Mrs John Constable and her two eldest children c1820. The happiness brought by his marriage released in the artist the mature expression of his genius. This little oil sketch is painted on the reverse of a Dutch painting from Constable's collection of Old Masters.

Family collection

Oil on panel

16.5 x 21.5 cm.

Windy Sky and Elms, a small watercolour which shows the simple and energetic approach Constable used when taking pictorial notes on everything he saw in the country.

Family collection *Watercolour* *13.5 x 11 cm.*

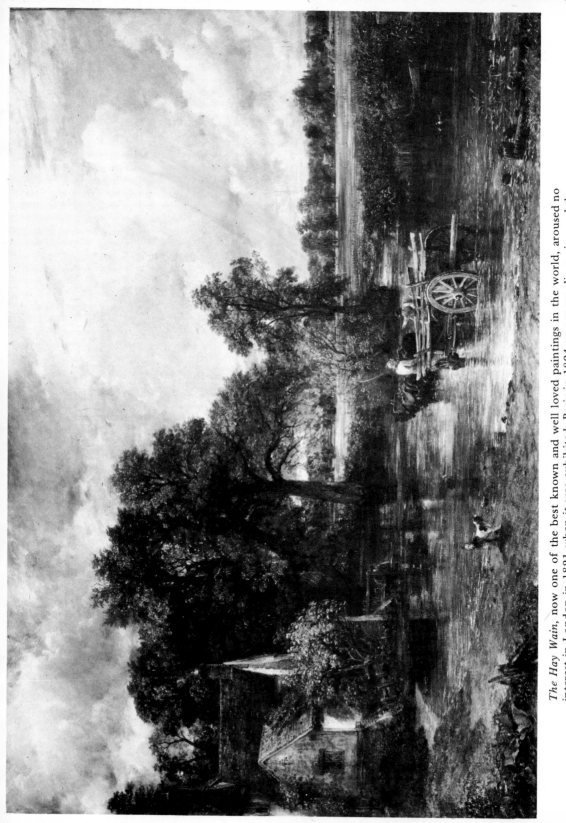

The Hay Wain, now one of the best known and well loved paintings in the world, aroused no interest in London in 1821 when it was exhibited. Paris in 1824 was more discerning and the ferment it aroused led to the modern movements in French art.

Reproduced by courtesy of the National Gallery, London Oil on canvas 145.5 x 185.5 cm.

In practical terms he had now come to the point of working his expressive sketches to his full use and turning the frenzied maelstrom of paint — of which they consist — into the finished picture. Sketches made of sparkling, almost violent, light around the pond give little immediate indication of the splendid stability which is such an important feature of *The Hay Wain*. But they were the underlying structure on which it was built, without them it would never have stood so firmly, so confidently. On another level he had taken his impressions of light, shade, air and water and through artistic instinct allied to intellect had faced his day of judgement at last, and had not been found wanting.

The picture was well received in the Academy but it did not set the town on fire and no purchaser offered for it. However, Constable could go off to Berkshire to accompany Fisher on his archdeaconal tour of that county well pleased with himself. During June he happily sketched the towns and rivers on the tour, never suspecting that among the visitors to the Academy exhibition were some from France who would be highly instrumental in shaping his future reputation. The French artist Gericault who had brought his great painting *The Raft of the Medusa* for exhibition in private rooms in London and Isabey, who was also impressed by *The Hay Wain*, talked much of the picture on their return to Paris so that other French artists were fired with interest. Another visitor was Charles Nodier who wrote a book on his tour of Britain and made it clear that Constable's painting was one of the most memorable sights of his visit.

For fresh air and to avoid any troubles which might arise from the coronation in July Constable took his family to Hampstead. He need not have worried, the grand display which placed the crown on the King's head was well received, Caroline's popularity of the previous year having evaporated there was little disturbance in the capital. Even when she arrived at the Abbey and was refused admittance to the ceremony, having no ticket, there was little interest.

Hampstead, 2 Lower Terrace, the house which Constable had taken to give his family air and the quiet regular life necessary to Maria's health had become a two-fold blessing to the artist. Although Maria's health worried him a great deal, her ailing brother had died and now her youngest sister Catherine was in a decline, Hampstead had begun to work on his artistic sensibility and he found he could now pursue intensively an already established interest, sky studies.

At this time Hampstead was far from either the artistic centre or the Londoner's playground it was to become. The popular image of artistic, radical Hampstead is comparatively recent. Before Constable went there George Romney had built a house in the village in the eighteenth century but does not seem to have practised his profession there. After Constable two of his contemporaries took houses but the growth of the artistic colony was slow. The census of 1851 shows 22 artists while that taken in 1911 shows 1,308. Originally one of the

manors of Westminster the village had always been largely agricultural with workings of sand and gravel. Its proximity to London gave farmers a ready market for their grazing and dairy products and this type of farming was still carried on in Constable's day.

In the late seventeenth century the craze for taking the waters had resulted in Hampstead with its chalybeate water becoming something of a mushroom town and was so successful that it acquired a pump room, assembly room and ball room. This flurry of fashion was soon over and Hampstead settled down to be a residential village for prosperous and respectable, professional people. Many were involved in finance, the law and medicine. No one aristocratic family held sway so that it had become a comfortable, moderate and bourgeois district.

For Maria in 1821 it gave opportunity for health and her husband realised from it some of his most unique work. This despite the smallness of the house where there was no space to spare and he was forced to rent a room at the local glazier's for his large painting, while to carry on with his smaller works, "I have cleared a small shed in the garden, which held sand, coals, mops & brooms & that is literally a coal hole, and have made it a workshop, & a place of refuge". The sketches made in oil around the Hampstead ponds form a complete unity of emotion, expression and scientific description. Scientific movements at this time were developing fast and were much concerned with the relationship between the elements of the natural world and their subtle dependence one on another. It was still the inspired amateur who was responsible for discovery and theory and Constable followed their announcements with keen attention. Two men's work interested him in particular, that of Luke Howard and Thomas Forster. As early

Tom and Jerry at the Exhibition of Pictures at the Royal Academy, an engraving made by I. R. and G. Cruikchank, published in 1821 shows society examining with varying degrees of interest the productions of the "face painters". The crammed method of hanging was normal practice.
The British Library *11 x 19.1 cm.*

Study of Cirrus Clouds, one of the sketches Constable made after he became interested in the latest scientific observations on atmospherics.

Victoria and Albert Museum　　　　　　*Oil on paper*　　　　　*11.5 x 18 cm.*

as 1803 Howard, a Quaker manufacturer of chemicals at Plaistow, had made known his nomenclature of clouds, giving them the names — cirrus, nimbus, cumulus — we still use. For this he was lauded in poetry by Goethe with Germanic fulsomeness. Howard made sketches to illustrate his observations of cloud formations and though they do not approach Constable's sky studies they are the first attempt at putting some order into the cloudy menagerie people saw in the sky. His book *The Climate of London* was published in 1820 and this, with Forster's *Researches about Atmospheric Phenoemena*, which reached its second edition in 1815, were read by and greatly aroused the curiosity of John Constable. As he read he tested the theories with his own observations and memories of watching the weather from the mills of Suffolk. He preferred the work of Forster but his copy of the book contains comments in which he disagrees with the author and by the passages marked shows his special interest in the processes of dew, vapours and condensation.

During these first summers at Hampstead he spent much time "skying"; in 1822 he made about fifty pure sky studies in addition to those sketches which feature the ponds with sky vast above. These ponds derive from natural springs and, although the activities of the Water Board in the late nineteenth century has affected them, the Branch Hill pond which is the centre for much of his work remains.

Mariabella Hodgkin, grand-daughter of Luke Howard and mother of the art critic Roger Fry, could remember her grandfather "always to be thinking of something very far away. He would stand a long time at the window gazing at the sky with his dreamy placid look". From the paintings he made on Hampstead Heath Constable was not the placid bystander watching the clouds move above him. An intense involvement is found in them and he would make a rapid sketch on the spot with all his concentration focused on grasping a particular situation as it occurred. In addition to studying the accepted forms of the clouds he was fully aware of what Forster had called "a determinable modification", those effects which a sky would present as clouds changed from their permanent to transitory features, these would give appearances which could not be referable to either. He was to explore these impermanent impressions in his work from now on and they contribute to the energetic truth which is such a feature of his late skies. No static convention or symbol is allowed to stand in for the exhilaration of fact.

For this he had already developed a technique suited to rapid outdoor painting. Sized paper was pinned into the lid of his painting box, spirit colours gave him fast drying as well as speed of stroke. Once home the sketches could be varnished to eliminate any "flatness" in the colour, and as this made the paper brittle sometimes the sketches were laid on to canvas. Many years before in Borrowdale he had noted time and weather on his sketches, now he made precise observations of time, date, wind direction. Despite some evidence that he was being merely practical and adding to his painter's repertoire (on one is written "Very appropriate for the coast at Osmington") of skies which could be used in future compositions, the heights of Hampstead gave him more than this. After years of working in London studios the panorama of the Heath gave him an emotional lift, a link with Suffolk and he could feel the same exhilaration as the swallows and martins, those favourite summer birds, as he painted them in the enormous space between himself and the clouds.

He felt the immediacy of sky and air in reality and realised the place they held in the creation of a landscape picture, "any specific effect of lighting on the ground is consistent with one, and only one, distribution of clouds and with one position of the sun in the sky".

Another development which Hampstead added to his pictures is found in the finished paintings he developed from the sketches made outside, and that is the use of the countryside for leisure. He often walked on the Heath with Maria when the weather was fine and in the paintings strollers are often seen taking the air on the paths which criss-crossed the Heath and so completing the scene in which men also herd animals or cart sand and gravel. In this he achieved the first synthesis between the two sides of man's use of the land and set them against a landscape grand but unembellished.

When he next worked on one of the large canvases of the Stour valley he incorporated into it his interest in the clouds. In *View on the Stour near Dedham*, they hang heavier over the river scene as they had never done before and the landscape lacks the enthusiasm which was so much a hallmark of his painting. The vigour of both execution and strength of composition have lost their ascendancy as he tries to incorporate his newfound discoveries into a large picture.

Constable told Fisher, "That landscape painter who does not make his skies a very material part of his composition – neglects to avail himself of one of his greatest aids. Sir Joshua Reynolds speaking of the *Landscape* of Titian and Salvator and Claude – says 'Even their skies seem to sympathise with the Subject'. I have often been advised to consider my Sky – as a 'White Sheet drawn behind the objects'. Certainly if the sky is obtrusive – (as mine are) it is bad, but if they are evaded (as mine are not) it is worse, they must and always shall with me make an effectual part of the composition. It will be difficult to name a class of Landscape, in which the sky is not the 'key note', the standard of 'Scale' and the chief 'Organ of sentiment' ". He continues, "The sky is the chief 'source of light' in nature – and governs everything. Even our common observations on the weather of the everyday, are suggested by them but it does not occur to us. Their difficulty in painting both as composition and execution is very great, because with all their brilliancy and consequence, they ought not to come forward or be hardly thought about in a picture – any more than extreme distances are.

But these remarks do not apply to phenomenon – or what painters call accidental Effects of Sky – because they always attract particularly.

I hope you will not think me turned critic instead of painter, I say all this to you though you do not want to be told – that I know very well what I am about, and that my skies have not been neglected though they often failed in execution – and often no doubt from over anxiety about them – which alone will destroy that easy appearance which nature always has – in all her movements."

Fisher was again a comfort when 1822 started inauspiciously with defeat at the Academy elections when, with no competition of any standing Constable was once more passed over. His friend cheered him with the prophecy, "the title of R.A. will never weigh a straw in that balance in which you are anxious to be found heavy, namely the judgement of posterity. You are painting for a name to be remembered hereafter: for the time when men will talk of Wilson, Vanderneer and Ruisdale and Constable in the same breath. And do not let your vision be diverted from this North star, by the rubs and ragged edges of the world which will hitch in every mans garment as he hustles through life."

Constable was sure in his heart that he was painting for the future and often referred to his paintings as "property for my children". But for all his discouraging experiences at the Academy he was always a supporter of that august institution

and though he may have endorsed Fisher's remark, "I have conceived that you have been hard at work on a six foot canvas, that you have outdone yourself: and having thus got the Royal Academy into a corner that you are poking your brush into their faces. This is at least what I wish you to do," he remained an Academy man all his life.

The financial strain of the house at Hampstead and an enlarging family were on his mind and in April he was thrown into a real quandary when a Parisian dealer, John Arrowsmith, offered £70 for *The Hay Wain*. Despite his English name Arrowsmith was an influential French dealer who was especially involved with the Romantic painters in France and he knew that the picture would create no small stir if he could take it to Paris. But the offer was well below the hundred and fifty pounds Constable had been asking for the painting in exhibition. He told Fisher, "I hardly know what to do — it may promote my fame and procure commissions but it may not. It is property to my family — though I want the money dreadfully."

He then had to ask for the loan of twenty or thirty pounds but this Fisher found impossible to provide. Another child was just born to him and his income may have been affected by the unrest in the country. Abram had written that Suffolk was as bad as Ireland with fires to be seen every night. After the high peak of victory over Napoleon England had not had the right leaders to push her forward into change and her people were not now prepared to settle back into the old ways again. Emigration reached enormous proportions, conditions were bad in the industrial northern towns but it was the decline of agriculture which spelt doom to many. There was much hatred of both government and church and non-payment of his tithes may have been the cause of Fisher's troubles. He could only send Constable five pounds and he, despite his needs, decided not to let *The Hay Wain* go to France. "I shall not let the Frenchman have my picture. It is too bad to allow myself to be knocked down by a French man. In short it may fetch my family something one time or another and it would be disgracing my diploma to take so small a price and less by over one half than I asked."

With another child due in August the house in Keppel Street seemed rather small and overcrowded and a change of home had become necessary.

The Constables' old friend Joseph Farington had died the previous winter and they now arranged to take his old house in Charlotte Street. It was a reluctant move, "I am loth to leave a place where I have had so much happiness and good fortune and where I painted my four landscapes," but he admitted they were like bottled wasps on a south wall so the change was essential though it strained their finances to the limit. Isabel was born at Hampstead, which was proving to her father an expense he could well do without, the skies might be useful to him but he complained that the place was ruining him by adding more expense to the

mounting cost of turning the house in Charlotte Street from a bachelor residence into a family home. Characteristically he applied himself energetically to fulfilling commissions this summer instead of visiting Fisher.

By now it was small landscapes and coastal scenes which brought in some extra money. Constable kept examples of his work of this type, a patron could choose what he wanted and his painting was then worked to order. Another picture on hand was to be *Salisbury Cathedral from the Bishop's Grounds* but it progressed slowly through the winter for the whole family were laid low by illness, their constant companion. He said to Leslie, "As every animal has its peculiar food, or prey, provided by nature, I look upon women and children to be the natural prey of doctors", but he was always on good terms with his medical attendants and in this instance paid the doctor's bills with a painting. His tart comment is typical of those remarks which won him a reputation for a sharp tongue amongst his fellow artists. Amongst those who knew him well he was a trusted and honest friend, it was the pretentious who could not bear the truth which he dared to utter, always with a civilised sarcasm which carried a delayed shock effect. He could reply to a request for his opinion in an auction room "the judgement of a painter is of very little value in such a place as this, for *we* only

Branch Mill Pond, Hampstead has the energetic freedom which the skies and pure air of the Heath released in Constable when he left the worries and closeness of London.

Victoria and Albert Museum *Oil on canvas* *24 x 39.4 cm.*

know good pictures from bad ones. We know nothing of their pedigrees, of their market value, or how far certain masters are in fashion," or comment on the work of a fashionable portrait painter, "he took out all the bones and all the brains". Honest as he was he expected others to be the same and could politely request his milkman, "In future we shall feel obliged if you will send us the milk and water in separate cans". His forthright manner won him friends among his social inferiors and the Academy students when he lectured in the Life class in years to come, but he was ever intolerant of the dishonest in any sphere.

When February brought the election for filling the vacant place left by Farington's death he again was disappointed. This time it was Reinagle, who in their student days had been so engrossed in dealing, who was elected. He was eventually to lose his diploma for exhibiting a work not his own but now the "most weak and undesirable artist on the list" entered the hallowed company and the chagrin of this added to the vexation of family worries for John Charles, the eldest son, after being a fine baby had developed into a delicate child whose health was a constant cause of alarm. And Constable himself faced preparing for the annual exhibition weak and emaciated from being bled by his doctors.

The picture of Salisbury Cathedral caused him some trouble for not only did he loathe painting the details of architecture but the Bishop had a liking for clear blue skies and was not quite happy about the one Constable had painted. Given the unrest in the country and the bad feeling which was still fermenting against the church he felt that it was not a good omen to see his cathedral under a cloud. However as the year progressed Constable's spirits rose and he allowed himself a stay with Fisher in August. The two friends visited, painted and talked pictures until mid-September when the ever-patient Maria at last saw her husband home again. Not for long, in October he was off to stay with Sir George Beaumont at Coleorton Hall. As usual she was left in London to deal with the children, her husband's visitors and business affairs.

Constable plunged into the glories of the Beaumont collection. The house was filled with great pictures, folios of prints and drawings, the grounds held monuments to artists and the regularity of routine in the household was tuned to Sir George's painting hours. The set regularity of painting times and meal times impressed Constable who was ever erratic in his arrangements. He revelled in the productive life which was achieved by such method.

In addition he was overwhelmed by a richness of fine pictures. Setting himself to work alongside Beaumont he copied paintings by his beloved Claude and delayed his return home time and again and even tried the limits of Maria's good nature. He wrote, "I do not wonder at your being jealous of Claude. If anything could come between our love it is him. But I am fast advancing a beautifull copy of his study from nature of a little grove scene, which will be of service to me

for life, and by being nearly finished will be worth something and a peice of property — it is so well. If you my dearest love will be so good as to make yourself happy without me for this week only — then I shall meet you again quite happy — and it will I hope be long before we are thus parted again." He tried to console her with, "beleive me I shall be the better for this visit as long as I live. I am sure I shall finish my pictures so much better — and my temper will be so much improved. Sir G. is never angry or pettish or peevish — and though he loves painting so much it does not harrass him. You will like me a good deal better than ever you did, indeed I think now I shall never be cross to my poor Fish again."

Poor Fish tried being casual in her requests for his return and quoted the children, "John says he supposes you will return next summer", but by 17th November she was quite openly put out, "I begin to be heartily sick of your long absence. As to your Claude I would not advise you to show it to me for I shall follow Mr Bigg's advice & throw them all out of the window.

Your friends begin to wonder what is to become of you — that great bore Peter Cox was here nearly an hour on Saturday reading the paper & talking of himself. I hope you will not admit him so often into your painting room, & Mr Judkin another of your loungers has been here once or twice."

Admitting that Sir George wanted him to stay over Christmas Constable tried to justify his long visit by explaining how hard he had been working but to this she replied, "I am sorry to hear you confined yourself so much to painting, everyone expects to see you looking particularly well after such a residence in the country. I beg you will go out every day. I shall expect you at the *end of next week* certainly, it was complimentary in Sir George to ask you to remain the Xmas, but he forgot at the time that you had a wife . . . Charley says papa will never come home."

After further delays the visit finally came to an end. Maria had her husband returned to her but had immediately to nurse him through an attack of facial neuralgia which probably stemmed from the tooth troubles which attacked him sometimes. She was finding that an artist's wife has a great deal to accept in addition to all the usual domestic worries of a large family.

The Moorhen startled off her nest: she appears in the lower righthand corner of Constable's great painting *The Leaping Horse.*

Family collection *Oil on millboard* *10.5 x 11.5 cm.*

Houses of Parliament, two watercolours made when they were burnt down on the night of 16th October 1834. Constable took his two elder sons to see the blaze.

Family collection *Watercolour* *8 x 10 cm. and 9 x 18 cm.*

CHAPTER FIVE

"To look carefully and take notice is wisest,
to paint – when it is possible – is finest."
Sainte-Beuve

JOHN Arrowsmith was still interested in *The Hay Wain* and in January 1824 returned to London and once more approached Constable with an offer. Assuring him of the great reputation the picture already had in Paris he even suggested that it might be purchased for the Louvre. Knowing that Fisher wanted first refusal of the picture Constable wrote to him of the offer and received the reply, "Let your Hay Cart go to Paris by all means. I am much pulled down by agricultural distress to hope to possess it. I would (I think) let it go at less than its price for the sake of the *eclat* it may give you. The stupid English public, which has no judgement of its own, will begin to think that there is something in you if the French make your works national property. You have long laid under a mistake. Men do not purchase pictures because they admire them, but because others covet them. Hence they will only buy what they think no one else can possess: things scarce and unique."

In Paris the interest in the picture was high because the two rival movements in art were preparing to do battle. The information that Gericault had imparted concerning the painting made the Romantic artists — those who were in revolt against the Neoclassic — regard Constable as an ally. David and Ingres, the two giants of Neo-Classicism were under concerted attack from younger men who wanted passion, colour and freedom in their painting. For convenience and chronological reasons Constable is often included under the Romantic heading by art historians but he was not one of those artists with their demand for mystery, conflict and abnormality in art. Constable's painting is completely involved with the interaction of nature and the elements and the life of man as creations of a benevolent god. He was nearer in intent to the men of science who were working hard at defining the interaction of sun, wind and water and their mutual effects as part of the whole than he was to the Romantic artists who demanded fear, death and gloom as inspiration.

When Constable declared that only one position of the sun with one particular wind would produce one effect of nature to him this was mystery enough. It is a mystery seen in the clear reasonable light of noon, not the guttering candle or cold moonlight. However, the feeling for nature which was stirring amongst French artists made them want to see his work. It held nothing of the conflict they were feeling, only in the painting of his last years did he come near

Salisbury Cathedral from the Bishop's Grounds. Constable put in many hours on different versions of this picture. The building itself proved a test of his patience as did the Bishop himself who liked a clear blue sky over his cathedral.

Victoria and Albert Museum *Oil on canvas* *87.7 x 112 cm.*

Chain Pier, Brighton. Constable's dislike for "Piccadilly . . . by the seaside" did not prevent him painting there. Although this picture was painted for the Academy exhibition he could not repress his interest in the fishermen's tackle lying in the foreground, just as in the Suffolk pictures he showed agricultural implements.

The Tate Gallery, London *Oil on canvas* *127 x 185.6 cm.*

to Romanticism, but then he was more in accord with the moral melancholy of the dawning Victorian age and his own despair forced a different visual experience through him. It is significant that although his late pictures would seem a contradiction in them he is faithful to his love of his own country. This would alone set him apart from the Romantics who yearned for the unattainable, suffered and despaired but did not *love* with a fulfilled and confident emotion any humble subject matter. The love and vision which his native country stirred in him was the most powerful element in his life and is what makes his painting the unique statement it is.

Arrowsmith bought *The Hay Wain* with the *View on the Stour near Dedham* and a Yarmouth seapiece for two hundred and fifty pounds and by the time they were crated for transport had decided upon three more paintings. Another French dealer, Claude Scroth, who was also involved with the Romantics and knew Delacroix, had ordered three paintings so that Constable could say with some satisfaction to Fisher, "I am more than ever involved with *business.*"

To this was added the satisfaction of knowing that his exhibition work *The Lock* was sold on opening day at the Royal Academy for one hundred and fifty pounds — and more than this, it had been bought by a man who was not a friend

so there was no doubt that the picture had sold itself on its own merit. Johnny Dunthorne had been sent up from East Bergholt to act as Constable's studio assistant and in May he helped his master pack the pictures for France. On the 26th Constable accompanied them to Charing Cross but no further. Steamers had begun a passenger service across the Channel in 1821 and the journey could now be made in three or four hours given good weather, but he made no attempt to take advantage of the easy passage. Fisher suggested a visit to the French capital together but Constable could not be persuaded to attend the scene of his greatest glory. After *The Hay Wain* was sealed into its case that day in May he never saw it again for it did not return to England until after his death and then finally entered the National Gallery at the end of the century.

Alongside all this business activity family affairs had also entered a new stage and a house was taken at Brighton so that Maria and the children could escape the London summer. More expense but he could tell Maria, "Do ride when and where you like — and see your friends. We can well afford it this season." He well needed to be able to afford it for Brighton "the marine side of London" was supreme amongst those seaside towns which had taken the place of the fashionable spa resorts. The sea was considered a cure for every ailment and condition and although society was not so exclusive as it had been in the spas Brighton could offer much to the genteel visitor in addition to the benefits of sea air. A round of amusements centred on the Public Rooms which were conducted on rules based

Constable was fond of all animals and even fed a house mouse which joined the numerous family pets during the summer of 1825 when Maria and the children were in Brighton and he remained in the London house.

Family collection *Oil on paper* *10 x 13 cm.*

on those of the Pump Room at Bath or, one could dance at the Assembly Rooms or choose from the latest romances at the circulating library where one could also see the latest style in gloves or the most fashionable shade of ribbon. Walks on the Downs, visits to the wells near Shoreham provided a change from promenading along the Marine Parade and Chain Pier in Brighton itself.

The Pavilion dominated the town, its royal patronage gave society an air of importance while the actual building itself, Mogul Indian, Chinese and fantastic gave an unreal feel to the place. With the Prince Regent to lead the way Brighton had attracted all sorts of eccentries so that it had a *fin de siècle* atmosphere which did not endear it to the somewhat puritan Constable. He described it to Fisher as "the receptacle of fashion and off-scouring of London. The magnificence of the sea, and its (to use your own beautiful expression) everlasting voice, is drowned in the din and lost in the tumult of stage coaches — gigs — 'flys' etc — and the beach is only Piccadilly. . . by the seaside. Ladies dressed and *undressed* — gentlemen in morning gowns and slippers on, or without them altogether about *knee deep* in the breakers — footmen — children — nursery maids, dogs, boys, fishermen — preventive service men (with hangers and pistols), rotten fish and those hideous amphibious animals the old bathing women, whose language both in oathes and voice resembles men — all are mixed up together in endless and indecent confusion. The genteeler part, the marine parade, is still more unnatural — with its trimmed and neat appearance and the dandy jetty or chain pier, with its long and elegant strides into the sea a full ¼ of a mile. In short there is nothing here for a painter but the breakers — and the sky — which have been very lovely indeed and always varying." And to another friend he could report, "This is certainly a wonderful place for setting people up — making the well, better — and the ill, well, so so — and if I may judge by appearances, Old Neptune gets all the ladies with child — for we can hardly lay it to be the men which we see pulled and led about the beach here."

He did concede that the fishing boats were picturesque but blamed them for being hackneyed exhibition subjects which harmed the cause of landscape art. Nevertheless he did a certain amount of painting while visiting his family at Brighton and one of the excursions he made with them prompted the remark which shows how deeply he appreciated a truth which has remained obscure to most artists since. "Last Tuesday, the finest day that ever was, we went to the Dyke — which is in fact a roman remains of an enbankment, overlooking — perhaps the most grand and affecting natural landscape in the world — and consequently a scene most unfit for a picture. It is the business of a painter not to contend with nature and put this scene (a valley filled with imagery 50 miles long) on a canvas of a few inches, but to make something out of nothing, in attempting which he must almost of necessity become poetical."

On the day after this excursion was made the Salon opened in Paris and the

Lock near Dedham, an oil sketch typical of many Constable made to study effects of light and colour on the familiar scenes of the Stour valley.

From the collection of Mr and Mrs Paul Mellon Oil on paper on canvas 11.5 x 16.5 cm.

two pictures which were the talking points of the exhibition were *The Hay Wain* and Delacroix's *Massacre at Chios* which owed its novelty effect to the Constable painting. While it had been shown in Arrowsmith's gallery before going to the Louvre Delacroix had been highly impressed and had closely studied the way in which Constable had achieved the sparkle of light and colour which made it so distinctive a work.

Beaudelaire described Delacroix as being comparable to a tiger who "watches his prey with no more tense and concentrated gaze than does our painter when his spirit is fastened on an idea". He fastened his spirit on to *The Hay Wain* and learnt from it the way Constable had built up a close texture made from small dry touches of paint in pure colour which created a luminosity he had never seen before. Delacroix had then gone back to his own exhibition piece and repainted passages on the figures which gave them the same effect of sparkling light which had so captured him in the English picture. Its reputation was therefore enhanced by the fact that such a man should have so readily absorbed and immediately put to use one of the things the picture had to tell the French painters.

Its creator meanwhile was more taken up with living between London and Brighton. In Charlotte Street Johnny Dunthorne took command of the house,

discouraging some of the many acquaintances who were always calling to waste Constable's time, keeping the work on hand progressing, for Constable was apt to get side-tracked, he ran errands and worked in the studio and was even lent to Sir George Beaumont to work on the outlines of a picture before Sir George took it over. This he often did for Constable himself when pictures were ordered from standard subjects.

The two men had a casual summer, they lived economically on quantities of the cheapest food in season, lamb and gooseberry pies and puddings; Constable took young Dunthorne to see the sights of artistic London including an evening party held in the galleries of the British Institution where "We were much entertained — we saw a great many people all in full dress — and the pictures were lovely by lamp light. . The hideous ugliness of all the company astonished everybody. We got home at 12 — & finished our gooseberry pie." This comment comes from the journal he kept and sent down to Maria at intervals in which he recorded the daily

The Leaping Horse is thought by many to be Constable's greatest work. In the bustle of activity on the tow path he places man against the background of nature and does not miss familiar details like the moorhen startled off her nest in the lower right hand corner.

Royal Academy of Arts *Oil on canvas* *136 x 178 cm.*

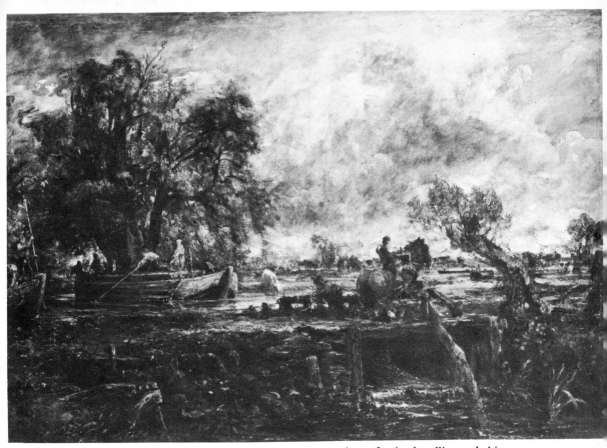

The full scale sketch for *The Leaping Horse* is a masterpiece of paint handling and chiaroscuro.
Victoria and Albert Museum *Oil on canvas* *129.5 x 185 cm.*

happenings in the house — the cats knocked over the flowerpots, his pigeons quarrelled and spoiled their eggs, a mouse in one of the rooms amused him and he started feeding it. He was intrigued by the balloon ascents which were made this summer over London and was also forced to spend much time looking at carriages for his sister Mary who wanted a vehicle to carry her up the steep ascent from Flatford Mill to East Bergholt. The difficulty of choosing such a thing for someone at a distance tried his patience but when the carriage was eventually received it caused "much envy and ill nature" in the village which did not worry its proud owner.

Constable was always closely involved with the domestic affairs of his family and now he was concerned for their welfare at a distance, to the extent of sending them food for which Maria gently chided him by pointing out that she could buy it in Brighton for the cost of sending from London. He could also send her the congratulatory letters and newspaper cuttings arriving from Paris but told her, "I hope not to go to Paris as long as I live. I do not see any end it is going to answer."

There is a certain pride in this indifference to French opinion and also in his statement, "Think of the lovely valleys mid the peacefull farm houses of Suffolk, forming a scene of exhibition to amuse the gay and frivolous Parisians." When Fisher joked of "plain John Constable not speaking a word of French" and plain John Constable chose to forget that he had taken extra French lessons at the end of his school days he was displaying a typical attitude of his time. The British withdrawal into an insular pride after the Napoleonic wars had been won was exacerbated by the economic difficulties and changes in the *status quo* which wars and years of uncertainty had brought. Cobbett's hated "change men" had prospered, reform was in the air and there were signs of a future created from mechanical industry but Constable, the true blue Tory, looked with the eyes of his eighteenth century background formed through independence and responsibility and did not go even halfway to meet the new way of life which was beginning. The old ways had been successful and he came from all that was best in England so he combined this conservatism with the national distrust of, and a certain amused contempt for, the foreigner.

The possibility that his picture might be bought for the French national collection pleased him, but he would have been more happy with the appreciation of the Royal Academy and British collectors, for all their ill treatment of him and his pictures. As it was, only a small group of friends valued his painting in England while in France he was hailed as the leader of modern art. In time he stands at the position of the last old master, the first modern, but during his life he was more concerned with getting recognition in his own country for his work.

One of his favourite quotations was "never mind the dogmas and rules of the schools — but get at the heart as you can" and this explains some of his reluctance to take more advantage of the wave of enthusiasm for him in France. He would sell paintings to go there if asked — did he not need the money? But he would not deliberately court success in Paris because he did not really believe that anyone born outside England could understand the heart of his pictures. *The Hay Wain* went to Paris because he needed the money and because he hoped that foreign interest in him might have some influence on his reputation at home. Stubbornly the home market remained unimpressed and he himself turned his attention to the next large canvas he would exhibit — *The Leaping Horse* — and this, with Maria's advancing pregnancy were two more reasons why he did not take up Arrowsmith's pressing invitations although there was the interest of the dealer's negotiations with the Louvre.

Eventually nothing came of the deal because Arrowsmith wanted to sell both paintings of Suffolk for five hundred pounds, the Louvre wanted *The Hay Wain* by itself. In January 1825 when the customary awards were made to those artists whose work was thought to have been of particular merit in the Salon, Charles X

handed out the gold medals. John Constable might have received his at the ceremony but as it was he had to wait three months for it to be sent.

The honour was appreciated despite his telling Fisher that his "early notice of me — and your friendship in my obscurity — was worth more, and in fact is now looked back to with more heartfelt satisfaction than all of these put together." And he could hardly conceal his pleasure in proudly saying, "I have added to the respectability of my family by making the family name a mark of distinction." His French dealers were still eager for more pictures and the birth of another child Emily, was an added pleasure, for him at least, for Maria had stated the previous year, "I am perfectly satisfied with my four without wishing for any more." Life seemed good when the Academy exhibition opened and *A Landscape,* later known as *The Leaping Horse,* was well received and his other exhibits, two views of Hampstead, were soon sold.

A number of artists were tempted across the Channel this year to see British art in its homeland, amongst them Delacroix who called on Constable bearing a letter of introduction from Scroth. He must have seen both the full size sketch and the finished painting of *The Leaping Horse.* This picture has the claim to being Constable's greatest masterpiece and it is very unfortunate that no record remains of the meeting between the two artists. Despite their very different backgrounds they had much in common when it came to their art. Both were tenacious and devoted to their painting, both appreciated the special qualities, the physical properties of paint and used it in ways which have scarcely been equalled since their time. It was a happy coincidence that *The Leaping Horse* should be the picture of the moment in Constable's studio for it would have captured Delacroix's interest immediately, the rich tones, full blooded texture, mainly produced by the palette knife, and sheer meatiness of the paint in both pictures would have been very much to his taste. The physical technique of his pictures is one of Constable's strong points, for being so aware that the materials of painting are a poor substitute for the light and shade of nature he applied much careful attention to his materials and no one could say as he did of Turner that some of his "best work is swept off the carpet every morning by the maid and put onto the dust hole." The effect on the French artist was far from transitory for in 1846 he recorded in his journal, "Constable says that the superiority of the green of his meadows comes from its being composed of a multitude of different greens. The lack of intensity and life in the foliage of most landscape paintings arises because they usually paint them with a uniform tone" and again in 1858 he wrote, "Constable, homme admirable, est une des gloires anglaises."

To Constable the picture showed that he was at last getting towards his goal, of making an art which existed as art and as Eric Newton has said, "His protest was against a habit of mind which had come to regard the art of painting as the art of impressing the mind by astonishing the eye."

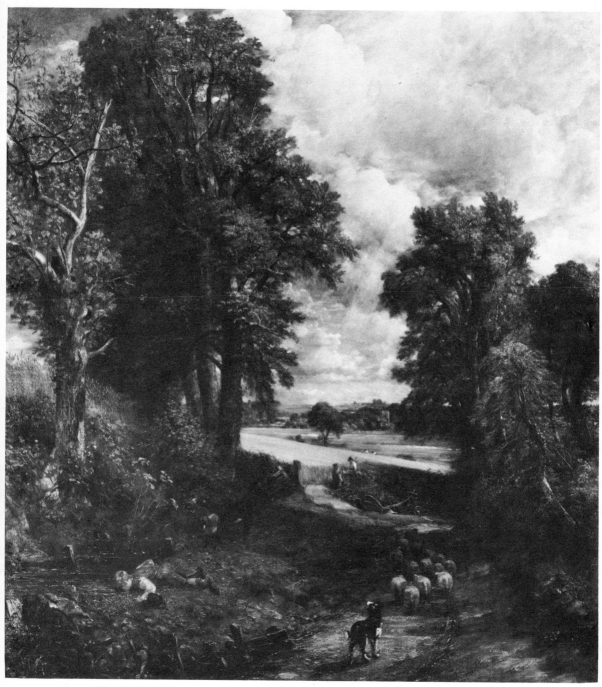

Constable admitted to applying "eye-salve" to make *The Cornfield* acceptable to the picture buying public but it aroused no interest.

Reproduced by courtesy of the National Gallery, London *Oil on canvas* *143 x 122 cm.*

The picture did not go totally unappreciated at the exhibition, one critic called it "A capital example of this artist's fresh, forcible and original style" but the majority of patrons still saw with eyes which required uplifting subjects and agreed with the sentiments expressed the following year by the Reverend John Eagles —

'Learn this, ye painters of dead stumps,
Old barges, and canals, and pumps,
Paint something fit to see, no view
Near Brentford, Islington, or Kew —
Paint any thing, — but what you do.'

This summer the British Institution held an exhibition of modern masters and Constable borrowed back *The White Horse* from Fisher and *Stratford Mill* from the long suffering Tinney who was constantly being asked to return his picture and after not seeing it for several months would discover that the artist had once more been at work on it. No amount of purchase money can remove a picture from an artist's possession, it always remains part of him.

After the exhibition and without Fisher knowing Constable had *The White Horse* shipped off to France, to an exhibition being held at Lille in place of the Salon. It won him another gold medal but this was overcast by the news that Arrowsmith had gone bankrupt. A general financial depression in France was making its first impact on the luxury trades, and picture dealing, especially that part which dealt with such unproved investment as modern art, was the first casualty. So the trade which had given Constable the prospect of ready money in a seemingly open ended stream was coming to an end. He did hear that Arrowsmith had finally sold *The Hay Wain* — 'the old home' for £400 but this was small comfort to his own finances which were once more strained by visits to Hampstead and Brighton for the health of Maria and John Charles. By autumn they were heavily overdrawn and Constable had to settle into working on what he called "my dead horses", commissions and copies to pay off the debts.

Having made such an impact in France he must have viewed the Royal Academy elections in the New Year of 1826 with some confidence. In January the President Sir Thomas Lawrence made a call on Constable in his painting room and admired work he saw there. But disappointment came once again, the two empty places were filled by artists far inferior, and added to this were his financial worries.

Times were getting bad all round and in Suffolk Abram was having a struggle keeping the business going and had no money to spare. Fisher offered advice, "Whatever you do, Constable, get thee rid of anxiety. It hurts the stomach more than arsenic. It generates only fresh cause for anxiety, by producing inaction and loss of time. I have heard it said of Generals who have failed, that they would have

For the sake of their health Constable finally settled his family at 40 Well Walk, Hampstead in 1827. This watercolour was made of the view over London from one of the windows.

Family collection *Watercolour* *9 x 10.5 cm.*

been good officers if they had not harrassed themselves by looking too narrowly into *details*. Does the cap fit? It does *me*."

Setting his sights firmly on the necessity of making some more money he worked hard at his major work for the Academy exhibition. "I am much worn, having worked very hard — and now the consolation of knowing I must work a great deal harder, or go to the workhouse. I have however work to do — and I hope to sell this present picture — as it certainly has a little more eye-salve than I usually condescend to give them."

The picture was *The Cornfield* and the first of his major works in which he turned his back on the Stour and looked down one of the paths he knew as a boy when crossing the valley to Dedham. The vigour of *The Leaping Horse* has been subdued, this picture gives a more generally acceptable look at the English countryside on a hot July day. Eye salve or not the painting did not sell then or at any time during Constable's life. In April, when it was despatched to the Academy, he very reluctantly sent his son John to school at Brighton. He was to be in the

care of Henry Phillips, a Brighton friend and botanist, who had supplied Constable with a list of appropriate vegetation for the foreground of the new painting. ". . . at this season all the tall grasses are in flower; bogrush, bull-rush, teazle. The white bindweed now hangs its flowers over the branches of the hedge. The wild carrot and hemlock flower in banks of hedges, cow parsley, water plantain etc: the heath hills are purple at this season; the rose-coloured persicaria in wet ditches is now very pretty, the catchfly graces the hedge-row, as also the ragged robin; bramble is now in flower, poppy, mallow, thistle, hop, etc."

Even though it was to a friend whose kind temperament he knew that he was entrusting his eldest boy Constable was such a doting father and still harboured his own bad memories of Lavenham school that the decision to send his son "John I'm afraid is a genius" was not an easy one.

In France it was now the turn of Scroth to feel financial difficulties and this put a final end to any further hopes of commissions from that country so that Constable had to take careful stock of his family expenses, Maria's health was not too bad so that he hoped "we shall not need a country excursion, in which we leave this convenient house, and pay four guineas a week for the privilege of sleeping in a hen-coop for the sake of country air." It was not to be, for an advancing pregnancy made a move advisable for her and they went to Hampstead while Mr Bicknell who had suffered an apoplexy attack was taken to Brighton to recuperate.

Alfred Abram was born on 14th November and even Constable who was devoted to children began to think that with six he had sufficient, "It is an awfull concern — and the reflection of what may be the consequences both to them and myself makes no small inroad into that abstractedness, which has hitherto been devoted to painting only. But I am willing to consider them as blessings — only,

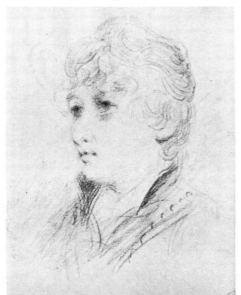

The tuberculosis which had destroyed her family finally claimed Maria Constable in 1828. This drawing from her last years shows how ill health had changed her.

Family collection *Pencil* *15 x 10 cm.*

that I am now satisfied and think my quiver full enough." For all his worries about their future his children gave Constable a security very necessary to him and his indulgent treatment of them was well known. He told Maria "I believe every child is ruined in body or mind by correction," and acted towards them accordingly. One delightful story related by Robert Leslie, the son of C. R. Leslie, gives a glimpse of him — "I remember how one of the older boys, after cutting holes in a large box to represent a house with windows, filled it with shavings and set fire to them. Another boy rang a small bell, and the model engine appeared, but had scarcely begun to play upon the flaming box when Constable, to whose studio the dense smoke had found its way, came among us, and saying, 'I can't have any more of this,' looked for a can of water to put out the fire; while the author of the mischief coolly turned the hose of the little engine on to the back of his father's head; who in place of being furious with the boy, as I expected, appeared to think it rather a good joke, and, after extinguishing the fire, quietly went back to his painting room." Another story which has survived comes from a visit made by Charles Mayne Young in order to view a particular painting. When the two men arrived in Constable's painting room they found a broom handle had damaged the picture. The fond father admonished his son with "Oh! my dear pet! See what we have done. Dear, dear! What shall we do to mend it? I can't think — can *you*?" Such mildness was a direct contrast with Constable's reputation in his professional world where he was known for uttering the most caustic comments in his "most agreable" voice.

With such a large brood and their mother's health rapidly declining Constable now decided that they would be better making Hampstead their main home and the house in Charlotte Street would be made his place of work and could even bring in a little money if part were let. Accordingly they moved into a house in Well Walk the next summer, it had everything Maria wanted and there was even "a view unequalled in Europe — from Westminster Abbey to Gravesend" to be seen from the drawing room window. Because of its professional occupants Hampstead had an excellent transport system, short-stage coaches made journeys between there and the City and West End. As many as ten coaches were used and the village had at least four times the share it could expect of transport on population grounds. It was therefore no difficult task for Constable to become a commuter to his painting room. It all cost money, though, and sales of pictures were not prospering. He had exhibited *The Marine Parade and Chain Pier, Brighton* at the Academy, the only one of his paintings to dwell on the contemporary scene. Despite it being of that most popular resort, showing the ever popular subject, boats, and being painted in much less vigorous manner and more in keeping with popular notions of 'finish' than his major works of late it did not find a buyer.

Money was so short that Constable had to apply unsuccessfully to Fisher for a loan. Nevertheless he carried out a cherished plan and took the two eldest

children, John and Minna, to stay at Flatford Mill during the autumn. The visit was a great success, fishing and a ride on a barge down the river brought back memories of his own childhood, as a proud father he took his own children to be admired by old friends in the village. They stayed in the Mill with Abram and Mary and, despite the fears of their uncle and aunt, did not drown in the pond.

While Constable was at Flatford his painting *The Cornfield* was on its way to Paris for the Salon in November — his financial difficulties had forced him to try and revive the French market. It was only two years since he was the talk of the Salon but although his reputation still stood high amongst artists there the artistic ferment in which his work had taken an important place was over and no one offered for the *The Cornfield*.

The disappointment made a gloomy start to 1828, Maria's safe delivery of another son Lionel Bicknell Constable on 2nd January was a relief but her constitution had been tried to its limit and received a further shock on 9th March when her father Charles Bicknell died. This foolish but amiable man could have eased some of her family anxieties during his life but did not. By his death his estate would be divided between Maria and her only surviving sister Louisa, and this would bring each some twenty thousand pounds. The thought of standing in front of a canvas with an easy mind may have helped Constable's chagrin at once more being unsuccessful in the Academy elections.

But he was now even more anxious that his wife should see him win the honour he so much desired. Much as he pushed the thought to the back of his

During the last months of Maria's life Constable was troubled by his patron Henry Greswolde Lewis with a commission to supply an inn sign for *The Mermaid and Greswolde Arms Inn* at Knowle. This was hardly flattering at any time but he made a sketch and this drawing.

Family collection Pen and ink 24.5 x 19 cm.

mind he could not help but see that she would never regain her health. When the Academy exhibition opened he wrote to Fisher with an account, "The Exhibition is poor — but though the talent is so small its produce is as usual in individual cases as well has been very great — £150 per diem, perhaps on average." Describing individual pictures he could say, "Turner has some golden visions — glorious and beautifull, but they are only visions — yet still they are art — and one could live with *such* pictures in the house.

Etty has a revel rout of Satyrs and lady bums as usual, very clear and sweetly scented with otter of roses." Yet he could not but reveal his true preoccupation, "My wife is sadly ill at Brighton — so is my dear dear Alfred: my letter today is however cheerful. Hampstead — sweet Hampstead that cost me so much, is deserted."

Maria was brought back from Brighton at the end of the summer so terribly thin and weak although her cough and fevered nights were improved. Putting his faith in the comfort and love of her own home Constable hardly dressed his grow-ing awareness of her condition with optimism, "her progress towards amendment is sadly slow, but still they tell me she does mend; pray God that this may be the case!" But by October the inevitable course of her consumption was so obvious that he could no longer conceal from himself the fact that she was dying and Leslie described a visit he made to the house and the effort Constable put into making things appear normal in her presence but, "he took me into another room, wrung my hand, and burst into tears, without speaking."

On 23rd November Maria Constable died and the marriage for which Constable had waited for so long and enjoyed for just twelve years was over. He was stricken with grief made worse by the fact that he had to care for seven motherless children, one of whom was still not a year old. But for them he could have abandoned himself to misery, but they had to be looked after, so many practical considerations had to be looked into and arranged. It was said that he wore mourning for Maria the rest of his life, and now his painting gave him the immediate outlet into which he could pour his grief after she was laid in the tomb at Hampstead parish church.

Hampstead Heath. Branch Mill Pond. During his life Constable was able to sell several of his Hampstead views like this while his Suffolk paintings roused little more than hostility.

Victoria and Albert Museum *Oil on canvas* *59.7 x 77.5 cm.*

A pencil drawing of Constable in his later years by Daniel Maclise.

National Portrait Gallery *Pencil* *11.5 x 14 cm.*

CHAPTER SIX

"Les vrais paradis sont les paradis qu'on a perdus"
Proust

LESS than three months after Maria's death Constable was elected a full Royal Academician. The news was brought to him in the evening of 10th February at Charlotte Street by his old rival Turner and the two men sat talking together until one in the morning. His general despair had left him little enthusiasm for the election and he had said to Leslie, "I have little heart to face an ordeal (or rather should I not say, 'run a gauntlet') in which 'kicks' are kind treatment to those 'insults to the mind', which 'we candidates, *wretches* of necessity' are exposed to, annually, from some 'highminded' members who stickle for the 'elevated & noble' walks of art i.e. preferring the *shaggy posteriors of a Satyr* to the *moral feeling of landscape.*"

He was setting himself to caring for his children and facing the problems of educating them. A housekeeper, Mrs Savage, "all that her name does not imply" and the children's nurse, Roberts, had taken over running the household while the widower, numb with grief and shock at losing her who had been at the centre of his life for many years before they actually married, worked on the painting which had come to symbolise his reaction to the catastrophe. The election news was greeted with great pleasure by Fisher but it was a hollow victory for Constable, "It has been delayed until I am solitary, and cannot impart it." Compared with his loss the honour of two letters after his name was a poor gain and when thinking of the long years in which Maria had supported him in his despair, frustrated ambitions and financial worries, the victory became a cruel twist, fate had given him money and the position he had desired, but it had taken the wife on whom he depended so much and for whom he had wanted the success.

His formally necessary visit to the President of the Royal Academy, Sir Thomas Lawrence, did nothing to rouse his enthusiasm, for Lawrence did not consider landscape a very high form of art and, although not unkind, pointed out that Constable was fortunate to be elected when there were many fine painters of historical works waiting to enter the Academy.

Constable was still feeling bitter when the varnishing days approached in April, "the Pandemonium opens to the devils themselves on Saturday — in which they are allowed every excess for six days (Sundays excepted)". This Pandemonium was the time given for varnishing and repainting works once hung, to make them look their best in the positions given to them. It was also the time for much rivalry with some artists trying to kill their companions' pictures — as Turner was shortly

to do to Constable — and was accompanied by all sorts of jokes, back slapping and back-biting.

His new work, *Hadleigh Castle,* was sent to this Pandemonium with some trepidation. It was his first exhibit since his election so would be looked at extra critically by those in his favour as well as those who did not consider his new status an addition to the Academy. There were even some who said that their own diplomas were devalued by his admission, which caused him to place more value on his. Leslie tells a story of an incident on one of the days during this year when *Hadleigh Castle* was hung, "Chantry told Constable its foreground was too cold, and taking his pallette from him, he passed a strong glazing of asphaltum all over that part of the picture, and while this was going on, Constable, who stood behind him in some degree of alarm, said to me 'there goes all my dew'. He held in great respect Chantry's judgement in most matters, but this did not prevent his carefully taking from the picture all that the great sculptor had done for it."

The pencil sketch for this view of ruins standing above the sea had been done many years before at the depths of Constable's despair during his courtship of Maria. The fact that he returned to it when laid low by her final illness and death shows that the melancholy scene with tempestuous sea had particular meaning. He was incapable at this time of working on his usual scenes of a felicitous countryside.

Hadleigh Castle attempts what he considered was no business of the painter, it takes a limitless infinity and fills it with emotion. That Constable succeeded in creating art and poetry, which can never be the *direct* expression of emotion but result from reflection (and he was fully aware of this) shows the stature of the artist. For despairing as he was over his wife's death he found in it no reason for doing less than his artistic genius would allow. The man grieved but the artist stood back, analysed and created from the emotion which had been released in him. The full title in the catalogue was *Hadleigh Castle, the Mouth of the Thames. Morning after a Stormy Night* and Constable added a quotation from Thomson's poem *Summer* —

> The desert joys
> Wildly, through all his melancholy bounds,
> Rude ruins glitter; and the briny deep,
> Seen from some pointed promontory's top,
> Far to the blue horizon's utmost verge,
> Restless, reflects a floating gleam.

Those words — glitter, restless and gleam, represent qualities which were becoming more and more important in his painting and which were gifts to the critics of the day. "Constable's snow" became common stock and *Hadleigh Castle* was as poorly received as he had come to expect his work to be, although the painting, now in

the collection of Mr and Mrs Paul Mellon, has not quite the wild turbulence of the full scale study for it (in the Tate Gallery). It is as if taken a short time after the sketch when the terrifying after effects of the storm have retreated a little, light is getting stronger and more equable and there is hope of a better day to come.

In painting the picture he had to some extent worked himself out of his depression and could take the two eldest children to stay with the Fishers at Leydenhall that summer. His last long visit to Salisbury had been in 1821 and now the country invigorated his tired emotions. The good sense and secure home of his friends, country air and subjects for his pencil and the pleasure of seeing two of his children enjoying a happy family home enabled him to quieten his grief and concentrate on work with a more tranquil resolve. Returning to London, he left Minna with the Fishers for a long stay. When he collected her in November this was his last visit to the Archdeacon at Salisbury as Fisher had only two years to live.

Hadleigh Castle was painted during the emotional stress of Maria's last illness and death. The drawings of this ruin on the Thames estuary were made in 1816 at a particularly difficult time in their courtship.

From the collection of Mr and Mrs Paul Mellon *Oil on canvas* *122 x 164.7 cm.*

A mezzotint from *The English Landscape* made by David Lucas from Constable's painting *View on the Stour near Dedham*.

Family collection *Mezzotint* *14 x 11 cm.*

The friendship which had supported Constable in more ways than one over the years now turned the other way and in December it was Fisher who felt debts pressing him hard and had to write, "Will it disturb you much, if I ask you whether you can turn your two great pictures into money for me? And whether you will say what you think they will fetch. Or if you do not like my parting with them, whether you will advance me £200 on them, they remaining in pledge. If I repay the money, they remain mine. If I am hereafter unable the pictures are yours again." He must have been in desperate straits even to suggest such a transaction, "I am grieved to part with them; but with six children I cannot afford to retain such valuable luxuries." Constable bought back *The White Horse* and *Salisbury Cathedral from the Bishop's Grounds,* perhaps he was even pleased because owning two of his best works would add to "property for my children" and would also give him ready access to them for another scheme which he had put into action. This was the publication of books of mezzotints to be called *The English Landscape.*

Friends had made the odd engraving of Constable's work right back to his first tentative efforts at home, after he had first met Antiquity Smith. Perhaps an offer from S. W. Reynolds in 1824, to make prints for Paris, had set the seed of the idea which he now put into practice. It turned out to be one of the most disruptive and costly episodes of his professional life and did not achieve his aim, which

was to bring the public status of landscape up to his own placing of it, and to bring his painting to a wider and, he hoped, more appreciative audience. To pay out good money to put such an aim into being may seem egotistical but he knew the value of his art and it was hardly vanity which had kept him painting all these long years with so little success.

The only suitable printing medium available for translating Constable's paintings was mezzotint, which was produced by tooling a metal plate to give it an all-over textured surface, rather like sandpaper. This could then be worked on with scraper, engraver or stippling tools to remove the texture in those parts where light was required, leaving rough those parts which had to be dark. It was essentially a tonal medium and so well suited to deal with the fleeting light effects and tonal masses of Constable's paintings, although his colour was lost. If not well handled the mezzotint could easily degenerate into something very nasty and vulgar, so the choice of printer to carry out his work had to be right. Constable chose David Lucas.

He was a farmer's son from Northamptonshire, so the two men had the same understanding of the countryside, besides which Lucas had liked to sketch landscape as a boy. It was his sketches which had by sheer chance won him an appren-

Popular with the students for his forthright manner Constable enjoyed his month spent as Visitor in the Life Class at the Royal Academy Schools in 1831. He himself was never an enthusiastic figure painter but a few studies like this have survived.

Family collection *Oil on canvas* *48 x 60 cm.*

ticeship to S. W. Reynolds when the famous engraver happened to stop at the farm one day in search of a drink. Brought to London, Lucas worked in Reynolds' studio and it may have been in 1824 when his master was interested in Constable's pictures that he met the artist. However he had set himself up in his own workshop in 1829 and it was to him that Constable entrusted the arduous task of producing the plates for the book which was to make his name for posterity.

Constable immediately took the upper hand in the work, worrying over the balance which he wanted in the collection of his works which was to be representative of the whole of his painting, the quieter moments of pastoral scenes set against the grander subjects like *Hadleigh Castle*. Right from the start he twisted this way and that, changing his mind, putting in and then discarding pictures or acting on advice from friends until he was utterly confused himself, and so the pattern of the years to follow was quickly established.

Ill-health dogged him now and comments on his and Lucas' health are one of the few signs of the common politenesses of life in the correspondence between them. Lucas kept every note Constable sent him and they make a monologue of commands, demands, reproofs, moans and doubts which he could excuse with "My indisposition sadly worries me and makes me think (perhaps too darkly) on almost every subject — nevertheless, my 'seven infants', my *time of life* and state of health, and other serious matters make me desirous of lightening my mind as much as possible of unnecessary oppression — as I fear it is already overweighted." And, "I am led to conclude of this definition of our book — finding that it grievously harrasses my days, and disturbs my rest of nights. The expence is too enormous for a work which has nothing but your beautifull feeling and execution to recommend it — and the painter himself is totally unpopular and ever will be, on this side of the grave certainly."

Lucas went on silently working and Constable continued worrying in every possible way. He reached hysterical heights in December 1831 when Lucas had taken it upon himself to make alterations to a plate of *The Glebe Farm*, a painting Constable had made in memorial to the Bishop of Salisbury because it showed the church at Langham, his first living. "Dear Lucas, Perhaps you had better send the picture of the *Glebe Farm* to Charlotte Street, where I will if possible try to look it over with your last proof — *hopeless* as it *now is* & I know *ever must be*.

How could you dear Lucas think of touching it after bringing me *such a proof* & without consulting me — had I dreamt of such a thing I should not have slept — beside I wanted at least *a dozen* of it in that state.

I know very well it can be *blotched* up, with *dry point burr*, regrounding, &c &c, but that is hatefull.

But I will say no more on so painfull a subject, for I wish you not to be vexed. It will retard the work — but we must not mind.

I am now writing with the *two proofs* before me and I frankly tell you I could burst into tears — never was there such *a wreck*. Do not touch the plate again on any account — it is not worth while.

But lose no time in grounding another, for I will not lose so interesting a subject. It would have saved the 5th number, & was it *now* in its first state, I would rejoice to publish it *just so*.

As to the London — it will do very well for the Londoners, & I should not have published it in the work had it not sufficed — but that plate is still safe. What caused you to *scrape off* the tree I do not know — *that dark* was essential there.

I could cry for my poor wretched wreck of the Glebe Farm — a name which once cheered me in progress — now become painfull to the last degree.

As the subject of the Glebe Farm is now lost, I have thoughts of substituting two new ones — the *Old House and Ford with a Waggon*, and the *Hadleigh Castle* — but that we will arrange on Tuesday.

I could cry at this sad change — & that with the *bird* once in my hand. I

The unpopularity of his painting *Salisbury Cathedral from the Meadows* did not deter Constable from having Lucas make a large mezzotint from it. On this proof he has stuck patches of white paper and added chalk marks to indicate where he wanted more highlight.

Family collection *Mezzotint* *56 x 69.2 cm.*

Waterloo Bridge from Whitehall Stairs, an oil sketch which captures the sparkle of light and colour which delighted the artist when he saw the new bridge opened by the Prince Regent in 1817.

Victoria and Albert Museum *Oil on millboard* *29.3 x 48.5 cm.*

know very well what you will say — that it can be brought about. *I* know better — our 'blasted Heath' proves what can be done only, in that way.

My opinion cannot change — my experience is now too great. If we keep the G.F. in the book, *ground a new plate instanter.* This is my dear boy's birthday — this day 14 years ago gave me my *first child* — we have had a party, & a feast — but my joy is utterly alloyed by the wreck of my poor Glebe Farm — which has not quitted my sight all day, though stretched and locked up in a drawer."

The letter continues in the same vein with more conflicting instructions which must have left Lucas completely at a standstill and only too sure of one thing, that he would never again touch a plate without Constable's instructions.

In fact the artist was so upset that later the same day another letter was despatched to the unfortunate Lucas, "But be assured, dear Lucas, the plate of the G.F. is utterly utterly aborted. It is & must ever be of that nature (do what you will), that it is *all* — *all* that I have wished to avoid in the whole nature of the work. The book is made by me to avoid all that is to be found there — a total

absence of breadth, richness, tone, chiaroscuro — & substituting soot, black fog, smoke, crackle, prickly rubble, scratches, edginess, want of keeping, & an intolerable & restless irritation."

Such a descriptive list could well be applied to himself but it must be remembered that rheumatism had struck him this autumn and he had even been for a time unable to stand. A further attack in the winter crippled his right hand. Fourteen leeches were applied to his shoulder but his son John had to take over writing the letters to Lucas. The frustration of immobility to an active man would have been great but was added to by Constable's admitted demon which drove him hard and also became frustrated working through other men's hands. He said of himself, "If I were bound with chains I should break them, and with a single hair round me I should feel uncomfortable."

Even after the fifth volume of *English Landscape* was published in the summer of 1832 he still messed about with the plates, making alterations to those which had been published, making plans for those which had been ground but not used — for he did not like seeing things for which he had paid going to waste. He was not happy over the success of the book, although it was well received amongst friends and artists it did not receive the financial support of the public for which

A view of Folkestone made on one of Constable's visits to his elder sons who were sent to school there for a short time.
Reproduced by permission of the Trustees of the British Museum Pencil and watercolour 12.7 x 21 cm.

he had hoped and he saw the cost of producing it taking from his children's future security. In another note to Lucas he says, "I have added a 'Ruin' to the little Glebe Farm — for, *not* to have a symbol in the book of myself, and of the 'Work' which I have projected, would be missing the opportunity."

Now that he was an R.A. the path was not smooth before his painting. In 1830 he served on the Hanging Committee and had the chagrin — although some said he deliberately engineered the "mistake" — of seeing one of his paintings insulted and rejected. It was probably painted during the peaceful time he had spent at Salisbury the previous summer and is one of the most tranquil works of his whole life. *Water Meadows near Salisbury* being brought into the selection room was dismissed, someone even saying, "Take that nasty green thing away". Academicians did not need to submit their work for selection, it was hung as a matter of course, but Constable insisted that having been rejected the picture should not be hung.

With so many calls on his time the friendship with Fisher, although warm as ever, was not supported by a continuous correspondence Academy affairs, the business with Lucas, his painting and his children kept Constable more than busy. His closest daily friendship was now with C. R. Leslie who lived just a walk from the Hampstead house and was also involved with the same professional problems. The letters to Fisher were now in the form of headlines concerning the main happenings instead of the close-set narrative they had been. They could still compare troubles and Constable had many: "The world gets fast hold of me — my comforts are now much lessened — and I feel my situation not wholly a bed of roses — malignity, envy and suchlike are the price of being eminent. My duty as 'Hangman', has not been the most enviable — it may account for some of the scurrillities of the newspapers, the mouths of which who can escape who has others to please? Still I have got through pretty well — with regard to my publick duties I have acted conscientiously and my mind is at rest.

I could give you some amusement about the Academy but I will not molest you. My Wood is liked but I suffer for want of that little completion which you always feel the regret of — and you are quite right. I have filled my head with certain notions of *freshness — sparkle* — brightness — till it has influenced my practice in no small degree, & is in fact taking the place of truth so invidious is manner, in all things — it is a species of self worship — which should always be combated — & we have nature (another word for moral feeling) always in our reach to do it with — if we will have the resolution to look at her."

These last thoughts disclose the rapid change which had come over Constable and his attitude to painting and in which he is an indicator of the country's mood. The Age of Seriousness was beginning and the foundations already laid for Victorian art in the world weariness at the end of the reign of George IV. The

illness of the king, the uncertainty of the succession and general dissatisfaction abroad in the country with the Reform Bill looming over all gives this period a hangover feel which affects everything about it.

Fisher himself had been very ill and was also suffering financial losses through three bad summers: "Times continue here as disheartening as ever. 'Summer has set in with its usual severity'. The rains have swollen the rivers, and swamped all our Dorsetshire meadows. The uncut hay is all muddled, the cows and sheep are tainted with coath: and every paddock is spoilt with what they call technically 'cows-heels'. This is the third consecutive year that this has happened: and in consequence, all my Gillingham farmers are ruined, and seven of them are now breaking stones on the road!"

The widespread unrest was such as to upset Constable who feared for the money he had invested in 'the funds' and for the fate of his England if the Whigs should bring about their dreaded Reform Bill. He was greatly afeared, "What makes me dread this tremendous attack on the constitution of the country is, that the wisest and best of the Lords are seriously and firmly objecting to it — and it goes to give the government into the hands of the rabble and the dregs of the people, and the devil's agents on earth — the agitators." He had described to Lucas seeing a street meeting, "I saw the 'mob' after I left you, and the mob orators — they were in a coal waggon hiding their heads — under a tarpaulin by which they 'like the ostrich' wrongly thought no one could see their backsides — but as I passed in the Omnibus in the rear, I saw nothing but their backsides. The audience consisted of a few dirty men and women holding infants in their arms and all wet through — there might be some 50 or 100, not more. I am congratulating myself that I did not catch my cold there."

As an Academician, Constable attended the coronation of the new king, William IV, when he saw "with my own eyes the crown of England put on the head of that good man". A curious description for him to make but the new monarch's patriotism probably appealed to Constable and his sailor's background is said to have given him a forthright honesty, not so fitting an attribute in a king as it is in a man. Once on the throne he disappointed Constable by showing Whig sympathies, and he deplored the fact that the Whigs were pushing their policies hard "because it is so long since they have had so very great a fool on the throne." The despair was soon past, the artist's mercurial temperament rose and he was busy about his close affairs once more.

The Royal Academy had taken up a large place in his life, in January 1831 he had spent a month as Visitor in the Life Academy. This duty he carried out with characteristic thoroughness. His forthright manner made him immediately popular with the students and the problems of arranging the model caught his imagination and with typical enthusiasm he set up an 'Eve' complete with a garden

of Eden made of branches brought from a friend's garden at Hampstead. Having had trouble with the police twice stopping his men carting the branches as they were taken to be thieves, he had to set about the problems of keeping the model warm in January; "The chimney to the gas lamps succeeds entirely — but we find it difficult to keep the room warm — poor Eve, shivered sadly, and became like a 'goose' all over." Despite his arrangement of greenery being taken for 'Christmas', which amused him, the affair was a great success and was followed by two male models set into poses taken from Michaelangelo's *Last Judgement*: then another female pose finished his month's work in the Life class. He found working amongst the students stimulating although it took place at the part of the year when he was gathering his energies to finish his own works for the exhibition.

When he went back to his own painting *Salisbury Cathedral from the Meadows* he felt depressed. The children's ailments worried him and the sale of the book was not going as he had hoped. Johnny Dunthorne was now set up in his own business as a picture restorer so Constable did not have company and help in his painting room, then, having finished his picture, he had to serve on the Hanging Committee which he did with his usual intense application. There were, of course, recriminations and complaints and this year he made the mistake of moving one of Turner's paintings (he maintained for its own good) and replacing it by one of his own. Though the two pictures hung closely near one another the fact of the moving caused an exchange of words between the two men.

Salisbury Cathedral had a mixed reception, it was called a vulgar imitation of Turner's freaks and follies, one critic claimed that someone had spoilt it by spotting whitewash along the foreground while another justifiably called it "a chaos", with its turbulent sky and livid light which the rainbow did nothing to dispel it is the most threatening painting he ever made. But some did appreciate the work calling it "a rich landscape" and continuing, "Mr Constable is emphatically an *English* painter; no artist can paint English Scenery, properly so called, with so much feeling and truth. We may perhaps object to this work that the sky is too much broken and too purple, and that the middle distance is too scratchy and 'speckly' but the extreme distance and the foreground are unsurpassed in Art". Another critic took a musical metaphor and likened it to a song "roared out by a coal heaver" with Mr Constable's usual characteristics "coarseness and vulgarity".

Although it approaches the needs of Romanticism the picture would not have raised any interest in France; the movement to which he had been so useful had now conquered and, moreover, been added to by the wave of Orientalism which swept Paris. The Salon was full of pictures on Oriental themes, Eastern costume was adopted and Delacroix was no bystander in it all. He had been sent to Morocco with a mission to the Sultan and the effect of North Africa immediately appeared in his work.

This direct contact with the East greatly affected art and literature and

some echo found its way across the Channel to add the interiors of harems to the Classical nymphs and Scottish clansmen who found public favour in the exhibitions. Poor Constable, always at odds with public taste! Only, he felt, in the lately formed National Gallery did landscape receive its just appreciation. There Poussin, Claude, Rembrandt and Rubens — largely through the generosity of the late Sir George Beaumont — were to be seen. The collection was kept in an overcrowded house in Pall Mall but plans were shortly to be brought forward for providing a special building in Trafalgar Square.

Independence in the artist is usually rewarded by starvation unless he can impose his own views upon the public and create a market for his work by sheer force of personality and business acumen. Private means saved Constable from starvation and at this stage of his career, when the two main forces in taste — the Neo-classic and Romantic — were almost thoroughly assimilated, his particular vision ought to have had a better chance of being accepted. But the emergence of art from these into the aesthetic anarchy and revolutionary movements of the later nineteenth century was nearly imperceptible and almost so quickly past that it makes no definite and easily defined chronological break.

English art slipped and slid from one to another and it was to be the twentieth century which found the worth of Constable. He himself was tied to tradition and fully appreciative of the virtues of continuity, seeing himself the follower of the great landscape artists of the past, translating his own time into art.

Constable never ceased to make pictorial notes from nature like this watercolour of honeysuckle.

Family collection Watercolour 20 x 12.5 cm.

Windmills were always an important element in the countryside and to Constable they had special interest.

Family collection *Pencil* *11.6 x 18.4 cm.*

Having determined at an early stage in his career what he felt was necessary in contemporary art he followed it through, the crisis of doubt coming to him at the same moment as it did to general feeling. Although they were not recognised, these works of his last years after Maria's death were fully contemporary and in accord, if that is not a contradiction in terms, with the extraordinary polyglot mixture of art which is covered by the Victorian blanket.

All that is associated with the Regency years, the raffishness, soft clinging muslins, spendthrift gaiety and clear morning light had disappeared. Oddly enough the Prince Regent, once he became King, had done much to dispel that which he had created and he ushered in a new type of monarchy. He renounced Brighton after 1827 and made state visits on which he became the model of kingly dignity and moral honour which the middle classes wanted to see reflected from themselves and thus set the pattern for future monarchs.

The gay attitudes and often cruel ways of the Regency gave way to industrial enterprise, far more cruel but carried on in the sacred name of Commerce and Christianity Ltd and the light graceful fashions in dress, building and manners were being overtaken by the heavy, concealing and pompous. Virginia Woolf described in *Orlando* how when midnight started to strike on the last day of 1799 and the new century was born a small cloud appeared in the clear sky which gradually grew until the whole sky was heavy with cloud. Rains and mists changed the climate, ivy grew on red brick walls. This is the feeling in the late paintings of

Constable, the moss was growing on him and the *Salisbury Cathedral* is the first major work in which not only is he aware of its existence but has welcomed it.

When he was ill with rheumatism it was this painting, which of course was unsold, which he had hung at the foot of his bed and despite talking of there being a bright side to things he quoted (incorrectly) from Milton —

These delights do Melancholy give
And I with her will chuse to live.

He took a backward glance at his past with the next major work *Waterloo Bridge from Whitehall Stairs*, a subject he had worked on for many years. The bridge had been opened in 1817 by the new George IV with great pomp, and the glittering scene of barges and regalia was the only picture London gave Constable for all his years of living there. It was a work he had returned to time and again but not until 1832 did the final picture arrive on the Academy wall, and an incident which occurred when it was hung was recorded by Leslie. It illustrates the rivalry which occured at the varnishing days and the superb self-confidence of Turner. "In 1832, when Constable exhibited his *Opening of Waterloo Bridge*, it was placed in the school of painting — one of the small rooms at Somerset House. A sea-piece, by Turner, was next to it — a grey picture, beautiful and true, but with no positive colour in any part of it. Constable's *Waterloo* seemed as if painted in liquid silver and gold, and Turner came several times into the room while he was

This early summer view of corn just before it starts to turn colour is a good example of the freshness and energy which Constable could capture in watercolour.

Family collection *Watercolour* *8 x 12 cm.*

heightening with vermilion and lake the decorations and flags of the city barges. Turner stood behind him, looking from the *Waterloo* to his own picture, and at last brought his palette from the great room where he was touching another picture, and putting a round daub of red lead, somewhat bigger than a shilling, on his grey sea, went away without saying a word. The intensity of the red lead, made more vivid by the coolness of his picture, caused even the vermilion and lake of Constable to look weak. I came into the room just as Turner left it. 'He has been here,' said Constable, 'and fired a gun'. On the opposite wall was a picture, by Jones, of Shadrach, Meshach and Abednego in the furnace. 'A coal,' said Cooper 'has bounced across the room from Jones's picture, and set fire to Turner's sea.' The great man did not come again into the room for a day and a half; and then, in the last moments that were allowed for painting, he glazed the scarlet seal he had put on his picture, and shaped it into a buoy.''

The picture had caused Constable many doubts during the dozen years he had been painting it; while attracted by the glitter of light and colour which the state barges made on the water he was not happy about departing from the rural — as he had said to Lucas in reference to the mezzotint of the scene, "As to the London — it will do very well for the Londoners". Transforming the splendid scene into paint was a challenge he accepted but his working of the paint with the palette knife was the main impression people received from the picture and it was generally unpopular. The brightness and colour stood for nought and Leslie says that the picture suffered a further fate "in little more than a year after his death,

The medium of watercolour could also be used to work up a more finished effect and Constable scratched into the surface with knife or brush handle, just as he did with oils, to get the strength of light he wanted. This view of *Old Sarum* was exhibited at the Royal Academy in 1834.

Victoria and Albert Museum *Watercolour* *30 x 48.5 cm.*

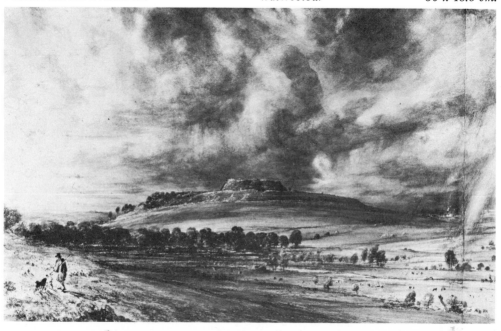

its silvery brightness was doomed to be clouded by a coat of *blacking,* laid on by the hand of a picture dealer! Yet that this was done, by way of giving *tone* to the picture, I know from the best authority, the lips of the operator, who gravely assured me that several noblemen considered it to be greatly improved by the process. The blacking was laid on with water, and secured by a coat of mastic varnish."

In this painting Constable had always had the particular interest of John Fisher but his friend's bad health of the last few years had become progressively worse and he probably was unable to visit the exhibition. On 3rd September a letter arrived at Well Walk announcing his death in Boulogne where he had been taken for a change of air. He was only forty-five and his death affected Constable profoundly. He wrote to Leslie, "You will be grieved to hear that I have lost my dear friend Archdeacon Fisher. He went with Mrs Fisher to Boulogne, hoping there to find some relief from a state of long and severe suffering both mental and bodily. He was benefited at first, began to take an interest in what was about him, & poor dear Mrs Fisher was cheered with the prospect of his being speedily restored to health and spirits — when on Friday August 24, he was seized with violent spasms and dead in the afternoon of Saturday the 25.

I cannot say but that this very sudden and awfull event has strongly affected me. The closest intimacy has subsisted for many years between us — we loved each other and confided in each other entirely — and this makes a sad gap in my life & worldly prospects. He would have helped my children, for he was a good adviser though impetuous — and a truly religious man.

God bless him till we meet again — I cannot tell how singularly his death has affected me.

I shall pass this week at Hampstead, to copy the winter piece — for which indeed my mind seems in a fit state."

To bury himself in work to ease grief was typical and the fact that he chose to copy a Ruisdael winter scene was symptomatic of his feelings for it was a season which never appeared in his own painting. It was a melancholy year for back in June he had noticed that Johnny Dunthorne was ailing, Leslie says he suffered from heart disease, and by July he could hardly walk, his legs being so swollen. Constable could then see that he might lose his friend "whose attachment has been like a son's from infancy. He is without fault and so much fitter for heaven."

These thoughts added to his fears for Minna who contracted scarlet fever that summer, she recovered and could be taken to convalesce at Dedham with her aunt Martha Whalley while Constable stayed at Flatford for a brief respite. His next visit to his country home was not so happy, Johnny Dunthorne had died in October and he travelled down to attend the funeral.

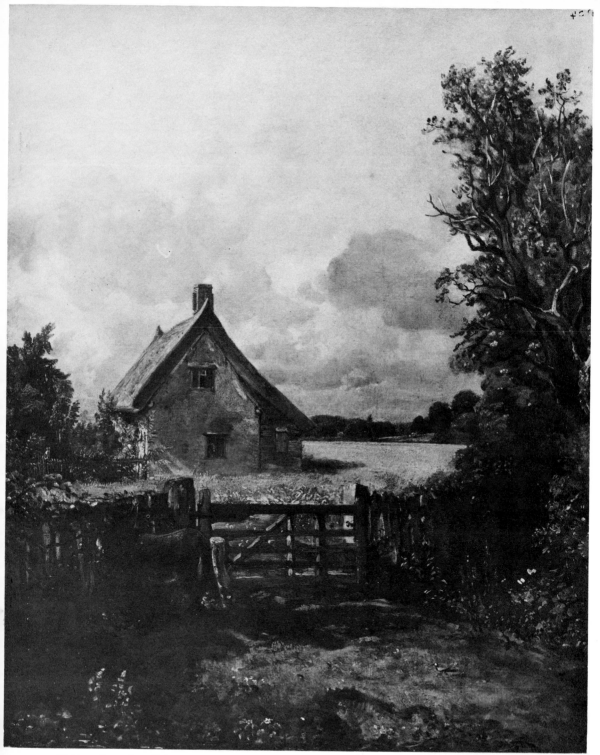

Cottage in a Cornfield was exhibited in 1833 but it looks back to the monumental pictures of his idyllic countryside of ten years before and is based on a drawing made in 1815.

Victoria and Albert Museum *Oil on canvas* *62.2 x 51.5 cm.*

CHAPTER SEVEN

"See, Winter comes, to rule the varied year,
Sullen and sad, with all his rising train,
Vapours, and Clouds, and Storms. Be these my theme,
These! that exhalt the soul to solemn thought,
And heavenly musing. Welcome, kindred glooms."

Thomson

THAT familiar road, full of memories, offered little comfort to Constable as he took the coach back to London a few days after the funeral. How many times had he travelled it, and with such despair or hope in his heart! His thoughts this time could not be other than gloomy, Johnny Dunthorne gone, Fisher gone, Maria gone — all much younger than himself. His older friends and patrons, Sir George Beaumont and the Bishop of Salisbury gone, at East Bergholt each time he visited new faces he did not know had taken the place of a few more of the old ones.

Thirty-four years of non-stop hard work and frustration lay between this morning and that one when he went to London to become a student. Now he was a full R.A., had it all been worthwhile? The critics abused him, the public ignored him, only a small band of friends appreciated his work. His thoughts were broken into by the spell of the countryside through which he was travelling, near Dedham, and he remarked to the other occupants of the coach that it was beautiful and received the reply, "Yes Sir — this is Constable's country!" Ever the cynic, "I then told him who I was lest he should spoil it." His stay had mixed melancholy with pleasure for the scenes which had meant so much to him all his life still made his hand reach for a pencil and the family were all living within short distances of one another, with Abram's hard work and business sense maintaining the mills and giving a continuity of family tradition.

On his return to London Constable set about the task of helping to dispose of Johnny Dunthorne's equipment from his picture restoring business, both he and Abram had to help Dunthorne with sorting out the financial side of his son's estate for he was very cast down by the death.

It was the quiet afterthought to the first artistic friendship of his life, although after the formal break the two men did not cut one another off completely. The Dunthorne cottage was so near to East Bergholt House and Constable must have made arrangements with the parents before taking young John to London although there had been no close friendship, but now grief for the dead made old differences unimportant. Abram still maintained that Dunthorne was

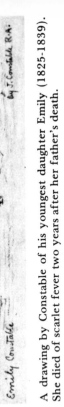

A drawing by Constable of his youngest daughter Emily (1825-1839). She died of scarlet fever two years after her father's death.

Family collection *Pencil* *15.4 x 11.5 cm.*

Charles Golding Constable (1821-1879) painted by Alfred Tidey when he was a midshipman on the E.I.S. Buckinghamshire in 1835.

Family collection *Watercolour* *10 x 7.5 cm.*

uncouth and bad mannered but Constable felt enough for him to send a pair of mezzotints of *The Lock* and *The Cornfield* after they were published.

At this time of Constable's life there is a turning back to his native country-side and involvement with his children who were growing up fast. His ambition was as strong as ever but he felt that time was getting short and he took extra pleasure in taking his elder sons to Flatford next summer, "We ranged the woods & fields, and searched the clay pits of Suffolk for the bones, and skulls, & teeth of fossil animals, for John — & Charles made drawings and I did nothing at all — but I felt happy to see them enjoy themselves."

He was always appreciative of the details of nature and could take a close interest in the boys' enthusiasms. But he saw it all as part of an overall plan, a fine tree, an atmospheric effect, minerals, plants and birds were united in his mind rather than separated into compartments of minutae. He often painted sketches of things he saw which interested him, a group of rushes, flowers, a bird but they were not seen as specimens through a magnifying glass and one cannot imagine him lying in the grass as Ruskin did, drawing each blade as it grew, although he well knew how it was and how it looked.

In 1835 Charles went to Suffolk and then travelled back to London on the family ship which was now under the command of a cousin, Captain Sidey Constable. From an early age Charles Golding had shown every interest in boats and the following year Constable had to take a step which must have been agonising for such a fond father. He saw his second son off as a midshipman on the East Indiaman *Buckinghamshire* bound for Bombay. Fifteen was quite a normal age for boys to start a naval career but how Constable must have suffered in allowing one of his brood to risk the perils of such a journey at such an early age.

It was not the first time of worry over Charles who was an energetic boy his father described as having, "A natural ardour and activity of mind and habit, with no great power of volition." School was not popular with him and at Folkestone where he had been sent, to be later joined by his brother John, he best liked to spend his time sketching the ships he saw there.

Constable's worries over his eldest son were centred on his health, which was never good, and the way it suffered from his studious habit. After the stage of building and wrecking was past John became very involved with scientific matters, dissecting animals, collecting fossils and minerals, shells and the study of the natural sciences in which he found his father's friend (but no relation) George Constable a natural ally.

These two boys' education had given Constable much concern, "I am sadly troubled and always have been with the education of my boys — they are not fit

The Valley Farm shows Willy Lott's cottage from its not so often seen rear side. Despite the cheerful house martins swooping over the water it is a gloomy picture and lacks what Constable liked in his work — health.

The Tate Gallery, London *Oil on canvas* *148.5 x 125.7 cm.*

for schools — how could I endure at my last hour the thought of wilfully plunging their early minds into *accumulative evil* — the real word for schools." Accordingly in 1831 he had employed a young man, Charles Boner, to act as tutor. When the boys were sent to Folkestone he stayed on as a general help to Constable and was so devoted to his employer that he sat up with him at night during the bouts of rheumatic fever. Constable's qualms about schools do not seem to have applied to girls for from an early age his daughters had been placed in a school at Hampstead where they were being brought up with all the accomplishments needed by young ladies. Minna, who was particularly fond of music, was the comfort of her father's life for he saw in her the wife he had lost.

When Boner went to settle in Germany in 1835 Constable braced himself and sent Alfred off to school at Hampstead and then faced the departure to sea of Charles. "I wish Charley well at sea — for his own sake. He is an extraordinary boy, and if his genius does not destroy him, it will be the making of him — but my *fear* is greater than my *hope*!! " he wrote to Leslie.

However by the time of packing the equipment — he maintained it cost two hundred pounds to send Charles off — melancholy set in, "Poor dear boy — I try to joke, but my heart is broken. He is mistaken by all, but you & me — he is full of sentiment & poetry & determination & integrity, & no vice I know of."

With Charles off to sea and Lionel sent to join Alfred in school at Hampstead, Constable and his eldest son could settle themselves into a quiet life together in Charlotte Street devoted to their work during term time. John was preparing to enter Cambridge, where he intended to take holy orders. He studied chemistry, anatomy and Latin and Greek and his application combined with his father's charm and strength of personality made his future look bright. His relations at Flatford highly approved of him and he was thought of as a perfect gentleman.

At the Royal Institution where he studied, one of his masters was Professor Michael Faraday, the leading scientist of his day, and it is probably through his son that Constable met Faraday and arranged the lectures he gave at the Royal Institution in 1836, when he claimed that landscape art should be given countenance as a branch of science. At Hampstead, which like other satellite communities fostered societies for appreciation of the arts and sciences, he had given a series of lectures on the development of landscape painting and in the autumn of 1835 he lectured in Worcester. In his talks he traced the history of landscape painting from the Roman frescos of Herculaneum up to his present time and in his introduction to the Royal Institution he placed himself in a unique position by declaring that his profession was scientific as well as poetic and that works stemming from the imagination alone could never stand comparison with realities.

At the end of the series, during which he had explored European painting in

detail as never before, he again defined painting as a science and finished with, "In such an age as this, painting should be *understood*, not looked on with blind wonder, nor considered only as poetic inspiration, but as a pursuit, *legitimate, scientific, and mechanical."*

1836 was the last time the Academy exhibitions were held in Somerset House and to it Constable sent *The Cenotaph* and a watercolour of *Stonehenge*. Neither had any connection with Suffolk but his thoughts were there as encouraged by his sister Mary's interest in purchasing property in the neighbourhood, he had become the owner of Old House Farm. The cottage opposite East Bergholt House was leased out and perhaps this farm was for retirement or to satisfy a longing for peace to paint clouds and trees, or perhaps as an investment for the children for, as Abram said, "The Land is a jewel in any times", but whatever the reason he was never to see his new property as owner.

Abram himself was as close to his brother as ever, Mary, whom Constable referred to as his "cracked" sister was becoming a little eccentric with age. Yet she still could keep her brother informed of all the family affairs from the proposed route of the 'rail road' to the difficulties of getting good potatoes. Ann was described as 'going to the dogs' quite literally for the costs of feeding her

A now lost pen and ink drawing of children by Constable whose love of his family was legendary. This photograph was taken by his youngest son Lionel (1828-1887) who was a keen photographer.

many animals made Abram say that they were eating her alive, and Golding was a law unto himself. Abram was having to pit his wits against poor trading conditions, "We are selling flour at eighteen pence a stone, the lowest price I ever remember it to have been at the milling trade in the country, and in London for country millers, is sad indeed, I am very uneasy about it, as I see no prospect of amendment". He still considered John as much a part of the family business as an eminent R.A. but this was the year when he had call to admire his brother's business talent for Constable had sold *The Valley Farm*, his major exhibition work, off his easel before it reached the Academy.

This was the first of his large paintings to be sold for eleven years, and as Abram said, "Few people can make a piece of canvass worth £300".

The recurring rheumatic fever had prevented him from keeping up with his oils and he had turned his attention often to watercolour. This may be a less tactile medium but he made attacks on his pictures in watercolour just as he did to the oils. The paint was handled in firm built-up strokes, no rapid washes were allowed to skate over the problems of form and composition. To get the light effects he wanted a knife or tip of the brush handle was scraped and scratched into the paper surface.

He worked at *The Valley Farm* all his professional life as many drawings and oil sketches for it are known. When enquiring of Leslie as to the progress of his exhibition work he said, "I am making a rich plumb pudding of mine, but it keeps me in a 'death sweat' — I am in a divil of a funk about it — and yet I like it and am confident". When the time came for despatch to the Academy he still felt it deficient in paint in some places.

His main works of these last four years of his life have an air of looking back and summing up his lifetime achievements, the *Cottage in the Cornfield* of 1833 is an immediate back reference to the masterpieces he had painted during the first years of marriage and which stemmed directly from his childhood. The two water-colours *Old Sarum* and *Stonehenge* look back to the good days of his friendship with Fisher when they visited these places and they have a finish on them which his friend would have approved. *The Cenotaph* is a most untypical picture showing the monument to Sir Joshua Reynolds in the grounds of Beaumont's estate at Coleorton. The idea was Regency, the picture Constable painted from it is Victorian with over-knitted drawing, a bleak autumn light emanating from a small tear of sky and only a dank puddle representing his all important element.

The Valley Farm was another look backward at the scenes of his boyhood, but how they have changed! the water looks slow and lifeless, the countryside is not purposefully at work, the farm house more a picturesque ruin in the making than a busy home.

The trees he loved so much are not growing in the air and light but decaying in a motionless dank gloom, house martins skim the water, but silently. It is an unhealthy picture, far more oppressive than *Hadleigh Castle* and was roundly attacked by the critics. One declared that Mr C ". . . ought to be whipped for thus maiming a real genius for Landscape." The flecks of white which he used to show dew received scornful treatment and were taken for sleet and snow, and even the sky upset one writer who saw it as the "tossing about of the stuffings of pack-saddles among remnants of blue taffeta."

After exhibition Constable followed his usual habit and resumed work on the picture; soon he was "oiling out, making out, polishing, scraping, &c. . . The 'sleet' and 'snow' have disappeared, leaving in their places, silver, ivory, and a little gold." Its new owner, Robert Vernon, was still waiting for the picture and getting fretful in December but Constable maintained, "I will do as I like with it, for I have a greater interest in it than anybody else."

That he had reached one of those periods in any artist's life when he questions all he has done is shown by the comment made to Leslie in a letter from Arundel in July 1834; "The Castle is the cheif ornament of this place — but all here sinks to insignificance in comparison with the woods, and hills. The woods hang from excessive steeps, and precipices, and the trees are beyond everything beautifull: I never saw such beauty in *natural landscape* before. I wish it may influence what I may do in the future, for I have too much preferred the picturesque to the beautifull — which will I hope account for the *broken ruggedness of my style.*" The interpretation of this confusing statement lies in distinguishing what he means by natural landscape, is it the uncultivated as against unnatural, those showing over-riding evidence of man's existence on which he had concentrated for so long. And what interpretation did he place on "picturesque"? To our eyes the painting he was working on when he died, of Arundel Mill and Castle, is picturesque.

Perhaps the word "striking" gives his meaning. In his major works he had long been working away from traditional canons and by his modernism had been startling and altogether too vivid for his time. By applying himself to what he termed beautiful he aimed at returning to those established canons wherein a grand and monumental, eternal truth could be expressed. He could never imitate what he termed the "old men", the great masters of the past. As he said, a new ruin is absurd, but he was increasingly conscious of the need to produce pictures which would bear comparison with art of the past.

Through his doubts he did not lose his interest in the how and why of the country, he was always alert to the individual characteristics of each place he visited and, while staying with George Constable at Arundel, he collected specimens of sand and earth whose colour pleased him and of a stay at Petworth

Stonehenge, one of the artist's few major works in watercolour. The stark magnificence of the stones is made even more dramatic by the rainbow — a favourite motif with Constable. Also a typical touch is the hare running out at the bottom left corner. This is painted on a separate piece of paper and stuck onto the painting.

Victoria and Albert Museum *Watercolour* *38.8 x 59.2 cm.*

Leslie, who was another guest, wrote, "I had an opportunity of witnessing his habits. He rose early, and had often made some beautiful sketch in the park before breakfast. On going into his room one morning, not aware that he had yet been out of it, I found him setting some of these sketches with isingglass. His dressing-table was covered with flowers, feathers of birds, and pieces of bark with lichens and mosses adhering to them, which he had brought home for the sake of their beautiful tints." So he was practising what he preached and admired in Claude and Poussin who though they lived, "surrounded with palaces filled with pictures, they made the fields their chief places of study."

It is perhaps pertinent that after that summer visit to Arundel he was once more at work on his *Salisbury Cathedral from the Meadows* which he felt that future generations would consider his finest painting for his opinion was that it gave the fullest expression of the compass of his art. It contained light, natural effects, the simple happening and the grand monumental but he is, like Claude in his late works, using grandeur of conception and composition to make up for what both men had lost, their greatest attribute "the calm sunshine of the heart". Constable found Claude's late pictures "cold, heavy and dark, though stately". In this statement from one of his lectures did he not sum up his own last paintings?

141

His spirits were not very high at this time and he said "though my life and occupation are useless, still I trifle on in a way that seems to myself like doing something: and my canvas soothes me into forgetfulness of much that is disagreeable." "Every gleam of sunshine is withdrawn from me, in the art, at least. Can it be wondered at, then, that I paint continual storms: 'Tempest o'er tempest roll'd'. Still the darkness is majestic, and I have not to accuse myself of ever having prostituted the moral feeling of the art." This moral feeling had changed during his working life into something completely different from that which he had regarded as moral twenty years before and his late works lose that quality he admired so much in his own pictures — health.

His physical health was never to make up for the crippling illness of the winter of 1833-34 and his thoughts were often gloomily introspective in the years which followed. Even in June, the best month of the year for his inspiration he could note "I never saw the elder bushes so filled with blossom, — they are quite beautifull & some of their blossoms forshortened as they curve over the round head of the tree itself are elegant. It is a favourite of mine & always was — but 'tis melancholy."

In August 1836 the *Buckinghamshire* docked and Charles was home. The unruly boy who had left for his first voyage had become a young man who had replaced many of his poetic notions of a life at sea with the facts of a hard reality. But the lessons learned had been good for him, he had acquitted himself well and his proud father was told that after his next voyage he would be able to take a junior officer's berth on any ship.

Milford Bridge near Salisbury a drawing which was used by Constable for one of his rare exercises in printing, he made an etching from it in 1836.

Family collection　　　　　　　　　　　*Pencil*　　　　　　　　　　　*11 x 16 cm.*

The etching of *Milford Bridge* made from the previous drawing.

Family collection *Etching* *11.5 x 18 cm.*

Pleasure at his son's success mingled with melancholy for hardly was Charley home than he was preparing for that next voyage. October saw London under deep snow and when he sailed for China in November terrible gales delayed the ship's progress, disturbing Constable greatly, and adding to his gloom over the parting. The trip to China and back would take two years, "I am not in the best of spirits. The parting with my dear sailor boy, for so long a time, that God knows if we ever meet again in this world, and its attacks on my dear children after I am gone and they have no protection, all these things make me sad." His feelings were justified for he never did see his son again, and had been dead four months before Charles learned of the fact in a newspaper in Bombay, where his journey to China was broken.

The winter was a hard one and it was the large oil *Arundel Mill and Castle* which kept Constable occupied. John was working hard at his studies before entering Cambridge, the family managed to escape the influenza epidemic and Constable also had Lucas working on a large print of his *Salisbury Cathedral* which met with more success than their previous ventures. It now came to be his turn at the Life Academy again and in February he took over from Turner as Visitor; even the bitter winds to which he was so sensitive did not prevent him from doing his duty. On the evening of Saturday 25th March he took the last

class held in Somerset House, after which a speech he made was heartily cheered by the students with whom he was very popular.

Arundel Mill again claimed his attention but on the following Thursday he attended the general assembly of the Academy in the new National Gallery building on Trafalgar Square and walked home with Leslie who described it — "as the night, though very cold, was fine, he walked a great part of the way home with me. The most trifling occurances of that evening remain on my memory. As we proceeded along Oxford Street, he heard a child cry on the opposite side of the way; the griefs of childhood never failed to arrest his attention, and he crossed over to a little beggar girl who had hurt her knee; he gave her a shilling and some kind words, which by stopping her tears, showed that the hurt was not serious, and we continued our walk. Some pecuniary losses he had lately met with had disturbed him, but more because they involved him with persons disposed to take advantage of his good feelings, than from their amount. He spoke of these with some degree of irritation, but turned to more agreeable subjects, and we parted at the west end of Oxford Street, laughing. — I never saw him again alive."

The next day Constable spent working on the picture and after going out on an errand connected with the Artists' Benevolent Fund he ate a hearty supper and went to bed. He had his bed warmed, an unusual indulgence, and once there read some of Southey's *Life of Cowper* before going to sleep. John Charles returned from the theatre and while preparing for bed himself heard his father cry out in great pain. A neighbour was called in who sent the servant downstairs for brandy, but before it could be fetched up Constable was dead. His doctors could find no cause but diagnosed indigestion.

When Leslie arrived next morning "he lay, looking as if in a tranquil sleep; his watch, which his hand had so lately wound up, ticking on a table by his side, on which also lay a book he had been reading scarcely an hour before his death.

He died as he had lived, surrounded by art, for the walls of the little attic were covered with engravings, and his feet nearly touched a print of the beautifull moonlight by Rubens, belonging to Mr Rogers. I remained the whole of the day in the house, and the greater part of it in his room, watching the progress of the casts that were made from his face by his neighbour Mr Joseph, and by Mr Davis.

I felt his loss far less than I have since done—than I do even now. Its suddenness produced the effect of a blow which stuns at first and pains afterwards; and I have lived to learn how much more I have lost in him, than at that time I supposed."

The sensitive John Charles was so stricken by his father's death that he could not attend the funeral a few days later, and so it was Abram and Golding who followed the coffin to Hampstead and watched, in the company of a few of his friends, as their brother was laid in the tomb beside Maria.

The death mask taken the day after he died shows John Constable to have retained the good features which had won him local fame in his youth as "the handsome miller".

Family collection *Plaster* *Life size*

Everyone agreed that so sudden a death was merciful in every way as Constable was so given to worrying over his children's future that he would have suffered extra pain during a long illness, but it left many problems. Seven children, two houses and hundreds of pictures had to be sorted out and cared for, but friends and relations rallied round John Charles who was soon to achieve his majority and could then legally take over his father's affairs.

The painter's death had done nothing to enhance his reputation and at the sale of his studio contents the buyers were more interested in his copies of old masters than in his own paintings. Oil sketches were sold at a few shillings a bundle and prices were so low generally that friends like Leslie bought in many works on the childrens' behalf and were then faced with storing them when the family moved into a smaller house in Cunningham Place.

Even those who professed to have the interests of his painting at heart had not the courage of their convictions when it came to choosing a picture to be presented to the National Gallery. The band of subscribers formed amongst his friends chose *The Cornfield* rather than one of his more original paintings. So it was by the one picture in which he admitted to bending to public taste and applying 'eye salve' that he first entered the British national collection.

In their new home Minna now became 'mother' to the family. Charles was still at sea and John went up to Jesus College, Cambridge and applied himself to his studies, being privately engaged to Mary Atkinson, the daughter of the architect of Scott's Abbotsford. He received a great shock in May 1839 for Emily contracted scarlet fever and died within a few days. The loss of his fourteen year old sister affected him very deeply and again he could not attend the funeral. Less than two years later he himself caught the same disease while studying in one of the Cambridge hospitals and died from it. This tragedy took the figurehead from the family ship and much of the responsibility for its security now fell to the lot of Minna and Isabel.

Minna devoted her life to this end while Isabel took up painting flowers and exhibited her paintings at the Royal Academy. She was exceedingly fond of animals which made her a natural admirer of the work of their friend and neighbour, Landseer. She is said to have collected strays off the streets and given them a home. Once, on bringing in a small dog, she fed it on the family lunch so that it was ever afterwards known as "Pie".

One of her friends, who shared her love of flowers, was Eliza Acton and on Isabel's request Alfred — who had decided to follow in his father's profession — presented her with some of his own sketches. Her letter acknowledging them shows how low a standing was given Constable's painting, "I shall keep his pretty sketches until he has become, — as I hope he will, — more famous than Wilson,

Charles Golding the only one of Constable's children to marry and have descendants. He became a commander in the Indian Navy and surveyed the Persian Gulf, his charts being still in use in the 1930s. This portrait is by Alfred Tidey.

Family collection *Oil on canvas* *36.5 x 29 cm.*

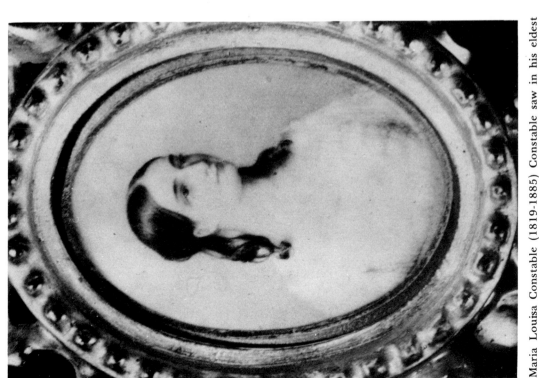

Maria Louisa Constable (1819-1885) Constable saw in his eldest daughter the image of his dead wife. A portrait by Alfred Tidey.

Family collection *Pencil* *6.5 x 4.5 cm.*

Turner, — or even my favourite Mr Edwin Landseer; and then I shall shew them with much *pomp* and pleasure as the work of his earlier years."

Both Alfred and Lionel painted with talent but on 19th November 1853 the boat in which they were crossing the Thames overturned and Alfred drowned. Lionel then lost interest in painting and spent his time boating and taking photographs. In 1859 he bought Fern Cottage at East Bergholt and was the last Constable to own property in Constable Country.

Of the large family only Charles married and had descendants. He was finally a Commander in the Indian Navy and distinguished himself by surveying the Persian Gulf — the chart he made was still used in the 1930s. He himself was no mean painter and took many views of scenes abroad. After his retirement from the sea he spent no small effort in declaiming against the forgeries of his father's work which were appearing on the market. Ironically these were mostly worked from the mezzotints by Lucas which Constable had so hoped would spread his name.

Isabel was the last survivor of this generation and so into her hands fell a large proportion of his pictures. These had not fulfilled his wish that they would be property for his descendants and they never did, for shortly before her death in 1888 she gave to the nation hundreds of oils, watercolours and drawings. Only portraits and a few works of personal interest were retained in the family possession, but these, added to those now in the national collections and the numbers sold off after his death, show what a prolific artist he was.

Constable's brothers and sisters all survived him for varying years, Abram being the last to die in 1862. But long before this he had sold the mills and land which the family owned. In 1846 an auction held at the *Golden Lion Hotel* in Ipswich dispersed the family business and property. Flatford Mill "with the machinery, going gears, flour mills, and tackle of every description, very spacious and excellent granary, with two floors, drying kiln, a convenient dry dock for barges, chalk wharf, and coal shed" was sold, with two miller's cottages, the house itself and a meadow, all for two thousand guineas. It continued to be worked for some years but before the end of the century the barge traffic was gone and the building, together with Willy Lott's house fell into disrepair.

In the 1920s, thanks to a local benefactor, the two properties were bought and saved. They are now in the care of the National Trust who allow the Field Studies Council to run a centre there for the study of local ecology, history and painting.

Abram ended his days living with a friend, Jacob Mecklenburgh, and was even remembered by local inhabitants in this century as a great raconteur and whist addict.

East Bergholt House cannot be seen for it was pulled down, it is said that the owners — the inhabitants of West Lodge — had it demolished as it spoilt their view and only resold the site on condition that nothing large was built on it. The present cottage known as "Constable's" was erected but a row of cottages, once the stables and laundry wing of the Constable family home, is all that remains of East Bergholt House.

The greatest memorial to John Constable R.A. and the one he would have wished, remains fairly intact: the Stour valley itself. Although an unimaginative main road slices across it at least it does carry through traffic away from the villages and it is easy to see his paintings as he himself once saw pictures in the countryside.

The great elms which stood around the mill pond at Flatford until early into this century have now gone and generations of willows have sprung up and died away since his time, changing some of the views. But it is the essential nature which he sought to capture which remains. It can still challenge and entice with an exceptional and unique light and clarity of air which even when subdued produces tonal contrasts unusual for Suffolk. In this he survives and will continue to be remembered in a way no museum or memorial can provide, for such things destroy the object they hallow and in his painting he created a synthesis between nature and man which has defeated Time.

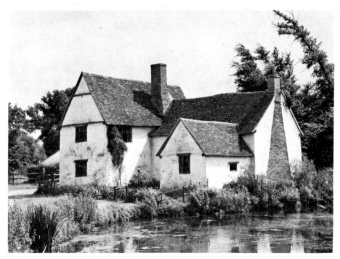

One of the best known buildings in the country, Willy Lott's cottage was restored and presented, together with Flatford Mill, to the nation by Mr T. R. Parkington of Ipswich in 1927. Today the cottage and mill are leased by the National Trust to the Field Studies Council for use as a Field Centre where courses on painting, local ecology and history are held.

East Anglian Daily Times.

INDEX